CHANGING REALITY
RECENT SOVIET PHOTOGRAPHY

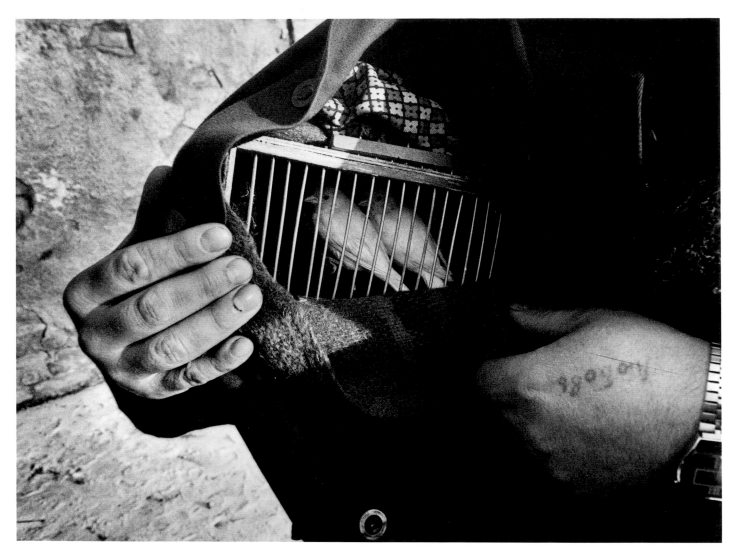

DMITRI VYSHEMIRSKY

Birds at pet market, tattoo reads "love" (also a woman's name)

Kaliningrad, 1986-87

CHANGING REALITY

By Leah Bendavid-Val

Starwood Publishing, Inc.
In Association with The Corcoran Gallery of Art
and Art Services International

RECENT SOVIET PHOTOGRAPHY

**For Avrom
and for
Naftali, Ronnit, and Oren**

By Leah Bendavid-Val

Museum exhibition curated by Frances Fralin, The Corcoran Gallery of Art
Museum exhibition circulated by Art Services International, Alexandria, Virginia
The exhibition is sponsored by the Professional Photography Division of Eastman Kodak Company.

Designed by Gibson Parsons Design
Edited by Carolyn M. Clark

ISBN 0-912347-76-7

Printed in Japan by Dai Nippon Printing Ltd.

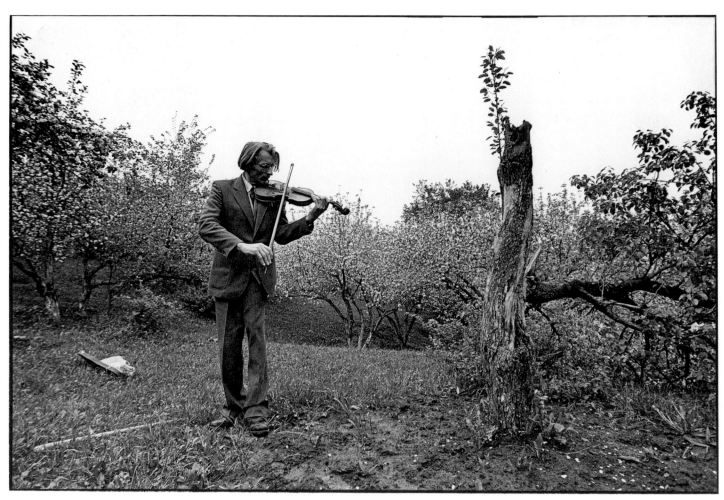

PAVEL KRIVTSOV
Violin teacher Dmitri Pronin
Oboyan, Kursk Region, May 1983

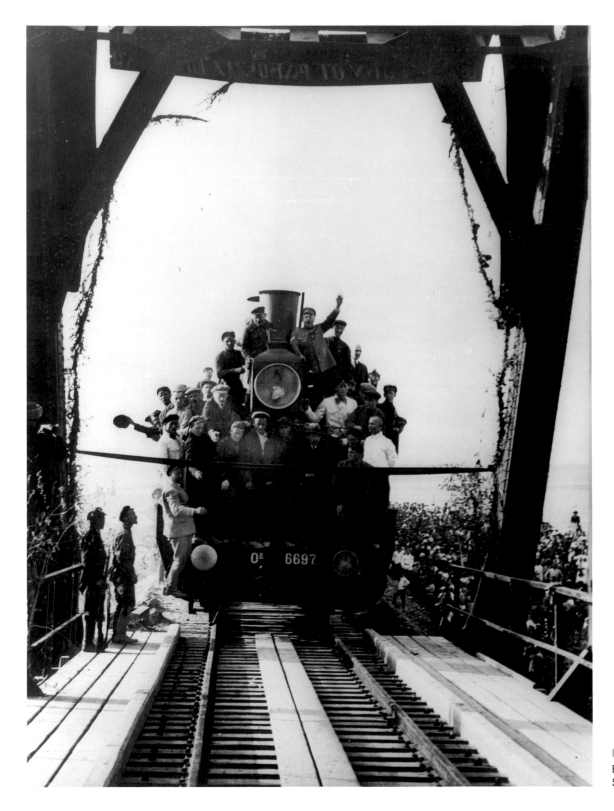

DMITRI DYEBABOV
First train on the Turkmen-
Siberian Railroad, 1939

SOVIET PHOTOGRAPHY: SOURCES AND CURRENTS

At five o'clock on the sweltering afternoon of August 18, 1989, a hundred men and women crowded into the austere gallery of the Journalists Union in downtown Moscow to attend a unique exhibition opening. No wine was served, or even water. The guests—photographers, archivists, and critics—fanned themselves and stood quietly through several ornate speeches. Then they turned their attention to an amazing set of photographs: Czar Nicholas II posing with his attractive family, Rasputin surrounded by his "female admirers," patriots taking an oath to the 1917 Provisional Government, and an array of Bolshevik luminaries in action, including the vilified Leon Trotsky delivering a speech at the Tomb of the Victims of Counterrevolution. Forty-five minutes later, most of the guests had drifted out into the slightly cooler air of Gogolevski Boulevard, and the exhibit entitled "Russia at the Turn of the Century" was launched for public viewing.

Until that Friday, most of the images in the show had been labeled subversive and locked away. Before Gorbachev's glasnost, the truth they held was considered too strong for public consumption. Photography in the Soviet Union, from the very outset, was thought to be so effective a means of influencing people, so indispensable an instrument of power, that it could not exist unsupervised.

Vladimir Ilyich Lenin knew that photography had been useful to Alexander Kerensky who headed the Provisional Government and to Czar Nicholas before him, and was anxious to harness it for himself. The Russian economy of 1917 was in dismal straits, and the new Bolshevik government was threatened by counterrevolution and foreign intervention. In the impoverished countryside devastated by the fighting, the vast and largely illiterate peasant population needed to be informed of the meaning of the revolution. This was the task Lenin and his colleagues had in mind for photography.

But when it became clear that the Bolsheviks were indeed in power, many photographers left the country or changed their profession. To respond to the shortage of skilled picture-takers in the postrevolutionary days, officials established the Higher Institute of Photography and Photographic Techniques in 1918. The institute produced an army of "worker and peasant photo-reporters" who generated hundreds of thousands of pictures documenting key events in the Soviet experiment and in the lives of selected model citizens. The new photographers were part of a far-reaching agitation and propaganda campaign called "agit-prop," whose goal was to awaken the masses emotionally and stir them to join the revolution.

Featuring simplified truths based on Russian folklore, agit-prop utilized not only photography, but also the avant-garde in literature, music, painting, theater, and film. The artists who joined the program were intoxicated by the

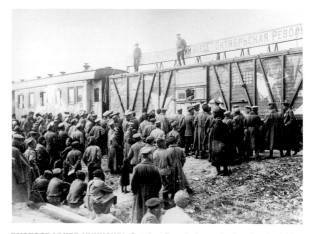

PHOTOGRAPHER UNKNOWN October Revolution agitational train, 1919

revolution, and they passionately committed their art to its cause. The notion that art should serve a political purpose was not new, but the multitude of forms taken by agit-prop and the extent of its reach were unprecedented:

slogan-laden agit-trains, agit-trams, and agit-steamers crisscrossed populated areas; murals appeared on public buildings; photographs were displayed on billboards; sculptures and monuments arose in public squares; theatrical spectacles, marches, and festivals were performed in city streets and villages; and albums and illustrated plates, fabrics, and utensils were distributed. The artists, their work infused with revolutionary purpose, looked toward a seemingly unlimited variety of expressive possibilities. Moscow painter Maria Siniakova, working in the midtwenties, said of those times, "Inside us we had youth and joy. We lived on art. Those were times of hope and fantasy."

The rural and religious people to whom agit-prop was directed believed in the salvation of the world, had a tendency to moralize, loved mysticism and ornamentation, and revered visible symbols of faith, especially icons. The saints pictured on icons suggested how worshippers should live, and by worshipping the images, the peasants felt part of a legitimate community of believers. Icon painters occupied a special position in society and lived by complex rules to insure their purity.

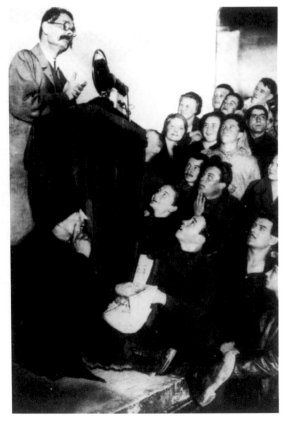

ARKADY SHAIKHET Maxim Gorky speaking before workers, 1929

After the revolution, photography, more than any other art form, appropriated the ancient role of the icon. Anatoly Lunacharsky, Lenin's commissar of education and shaper of policy on photography, described the photograph as "not merely a chemically treated plate—but a profound act of social and psychological creation." The photographer was not only a reporter, but also a generator of myths. These myths entailed nothing less than the creation of a New Soviet Man and a vision of how he would change the world.

Meanwhile, landscape photography and studio portraiture were declared degenerate relics of bourgeois society. These genres virtually disappeared from the Soviet art scene, never to regain the stature or the quality of prerevolutionary times. "Even today," according to Vadim Gippenreiter, currently the only widely acclaimed Soviet nature photographer, "no one takes pictures of nature seriously, and no one properly photographs nature in the USSR."

Those who stuck with the permitted types of social photography reached brilliant heights of creativity through experimentation. During the twenties, two schools of social reporting emerged: one traditional, one radical. The first was based on the documentary style of the late nineteenth century; the other was adapted from avant-garde graphics and departed dramatically from convention to create oblique, abstract, and transformed views of ordinary objects.

One of the earliest to whom the traditional approach can be traced was Maxim Dimitriev who, as early as the 1870s, made pictures of homeless shelters, boisterous fairs in Nizhni-Novgorod (now Gorky), retreats of a religious sect of Old Believers, and, in 1881 and 1882, famine in the Volga Basin. Soviet critic Sergei Morozov compares Dimitriev's work to that of Danish-American immigrant Jacob Riis, whose photography publicized the plight of Manhattan tenement dwellers at about the same time.

Also in the straightforward documentary tradition, but more neutral, were images from Karl Bulla, a German who opened a news agency and portrait studio in St. Petersburg (now Leningrad) in the early 1880s. His purpose was to supply the West with pictures of Russia, and for this he employed photographers to record the country's industrialization—workers in steel mills, mines, and textile and leather factories.

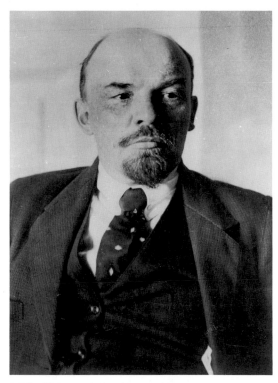

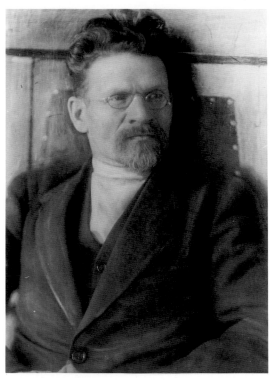

PYTOR OTSUP Vladimir Ilyich Lenin, Moscow, 1918 **P. S. ZHUKOV** Mikhail Ivanovich Kalinin, Moscow, 1920

Photojournalism as an active response to current events arrived in Russia, as it did in the West, with the twentieth century. The Russo-Japanese War of 1904 and 1905 especially stimulated Soviet photojournalists. Viktor Bulla, Karl's son, went to the front lines to cover the fighting firsthand. A young photographer named Pyotr Otsup engaged in a variety of daring exploits, among them sneaking into a private residence to photograph Rasputin for the French magazine *L'Illustration*. He also photographed the abdication of Czar Nicholas II, the street demonstrations surrounding the February Revolution, and the October 1917 attack on the Winter Palace.

After the October Revolution, Otsup continued to risk his life covering the battles of World War I and then the Soviet Civil War. Viktor Bulla was made director of the Soviet photographic studios in Petrograd and documented political events: Lenin giving speeches, dignitaries attending meetings, and workers gathering for demonstrations. Several prerevolutionary portrait photographers attached themselves to the Bolshevik cause and made official portraits that had the distinctly Russian iconographic power. Among the portrait makers were Minsk photographer Moise Napplebaum, who had been in the West and was influenced by Alfred Stieglitz's pictorial philosophy and the international Photo-Secession movement, and Abram Shterenberg, who was influenced by Napplebaum.

Alexander Mikhailovich Rodchenko was the leader of another group of photographers who embraced a radical, daringly modern brand of photography. A graphic artist before becoming a photographer, Rodchenko rejected art generated purely out of aesthetic concerns with the same vehemence that he rejected the bourgeoisie. He expressed his viewpoint with the feisty declaration, "Down with ART, the shining patches on the talentless life of a wealthy man."

Rodchenko, who began to photograph professionally in 1924, rapidly

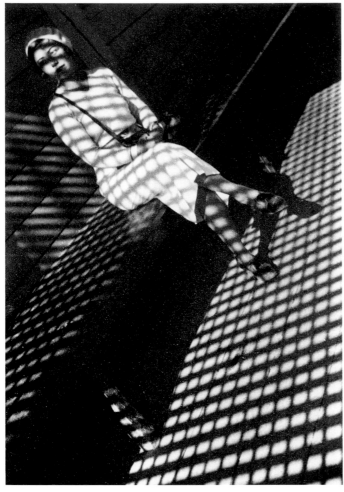

ALEXANDER RODCHENKO GIRL WITH LEICA, 1933

It did not take long for Rodchenko's unique photographic angles to be disparaged as "formalist." He was accused of favoring composition over content. Rodchenko did, in fact, apply principles of the literary formalists of his day, who decreed that art depended upon "estrangement" or "alienation." This meant offering the reader or viewer a surprising vantage point from which to observe the chosen subject. Rodchenko believed that the unexpected abstraction would force viewers to interpret the images, thus engaging their minds and emotions.

He was interested in process and rejected the static moment, the stationary view of an object; for him, a single photo encompassed no more fact than a single movie frame. To embrace more of reality, he began to photograph in cycles. In 1932, he completed a series of 2,000 photographs of prisoners constructing the White Sea-Baltic Canal, trying to capture a pride in Soviet technology and a belief that this use of prisoners would transform them into productive members of society.

He contributed his design, his philosophy, and his photographs to one journal after another. In 1928, in *Novyi Lef* (*New Left*), he wrote, "For us, the photograph of a new factory is not just a picture of a building, not just a factual record, but an expression of pride and joy in the industrialization of the land of the Soviets. This is what we must learn to capture in a photograph."

That same year, he helped found an artists' group called Oktiabr (October). Other members included Sergei Eisenstein, Diego Rivera, El Lissitsky, and photographers Eleazar Langman, Dmitri Dyebabov, and Boris Ignatovich. In June 1930, they mounted an exhibition in Moscow that included Rodchenko's photography. Official response ranged from bewilderment to anger. Rodchenko's was the kind of art Stalin detested. Immediately following the exhibit, the government forced Oktiabr to adopt an "antiformalist" platform. In 1931, the group expelled Rodchenko for his efforts to "put proletarian art on the path of Western advertisement art, formalism and aestheticism." From then until the group disbanded in 1932, it spoke out

became an innovator. Portraits of his mother and of his friend and collaborator, writer Vladimir Mayakovsky, were ground-breaking. His experiments in photography grew out of his earlier painting style: either he used diagonals, sometimes employing one as the axis of the picture, repeated and modified a single basic form, or laid down a grid which organized his image. His most dramatic innovation was the use of extraordinary angles of observation—"from all viewpoints, but not from the belly button." His pictures were meant to represent the energy of industry, the dynamics of the socialist society to come.

against abstract "leftist" photography by foreigners and Russians alike.

Even today, Rodchenko's experimentation with form remains controversial in the Soviet Union. For Leonid Bergoltsev, an award-winning establishment photojournalist and the chairman of the Moscow Union of Photographers, Rodchenko was not a photographer at all, but rather an artist with a camera in hand. Bergoltsev complains that Rodchenko did not utilize photography's specific attributes but relied instead on the painting techniques of the time.

While Oktiabr was establishing itself at the end of the twenties, a group that repudiated Oktiabr's style, the Union of Russian Proletarian Photogra-

phers (ROPF), was also forming. This society, led by the pictorial news photographers Arkady Shaikhet and Max Alpert, argued that the new socialist photography must be a straightforward record of the day's significant events; their intention was to continue in the tradition of Bulla and Otsup. But in Shaikhet's photos, the documentation was anything but neutral. Through his lens, he managed to transform everyday occurrences into potent symbols. In his photograph entitled "Ilyich's Small Lamp," for example, newly installed electricity in a rough peasant hut evokes the light—political, spiritual, and technological—that would bring Russia out of her dark past.

Though Oktiabr experimented with form far more than ROPF—and on

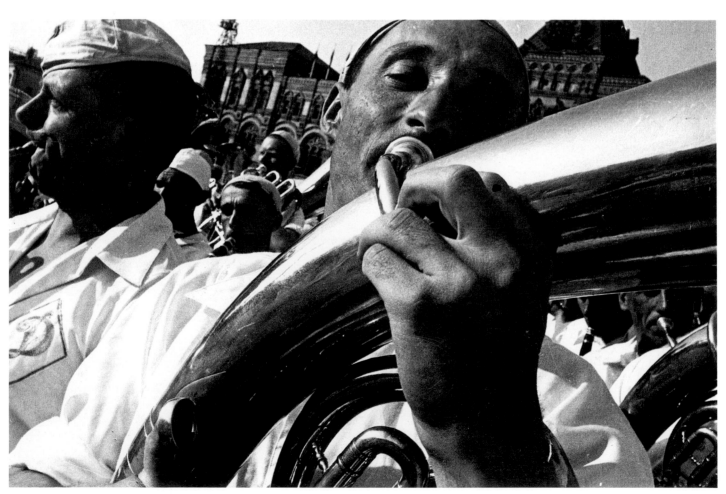

BORIS IGNATOVICH BRASS BAND, 1935

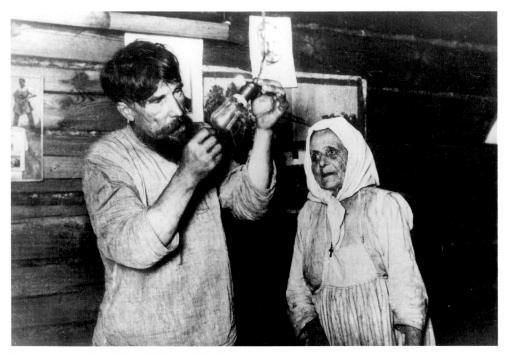

munist revolutionary ideals: heroism, technological progress, and healthy, aspiring masses.

Indeed, by the 1930s, the mood of the country had changed. Stalin was quite firmly in power and under his direction photographs were not only subject to censorship, but actually altered for public consumption. Stalin took the trouble to go back to pictures made in 1920 and earlier to airbrush out those whom he had purged from the party—to eradicate them from history as well as from his immediate presence. Leon Trotsky was a primary target of the airbrush, though certainly not the only one. And Stalin used the talents of the retouchers to make himself appear taller and stand closer to Lenin than other Bolsheviks whom he feared as competitors.

The first editorial printed in the illustrated magazine *USSR In Construction*, founded for foreign consumption by writer Maxim Gorky in 1930, stated that "photography must serve the country, not in a haphazard, unsystematic way but constantly and according to plan." On April 23, 1932, the Communist party published a resolution proclaiming the reorganization and unification of artistic and literary organizations. The multiplicity of art groups was abolished. Rodchenko was not the only one who fell into line—his followers did likewise. By the mid-1930s, the spontaneity and the rich variety of styles and opinions of the 1920s had diminished drastically.

It was not only pressure from the authorities that destroyed the artists' exuberance. Their spirit had already been weakened by witnessing the government's growing list of social failures: the emergence of a privileged political elite, the lack of equality in the economy, and the brutality with which collectivization and industrialization were implemented. The artists no longer believed in their work.

They were now assigned prescribed scripts. Their products went un-

these grounds the groups hurled accusations of disloyalty and incompetence at one another—both worked toward the same social ends: to document photographically the young state's achievements in fighting economic backwardness and illiteracy, and to describe with optimism strides toward industrialization, the collectivization of agriculture, and scientific progress. Industrialization had grown into a powerful and beautiful ideal, a metaphor for the socialist future, a way to escape an entire painful phase of history. (Americans were also worshipping the power of the machine at this time. Some equated technology with the functional beauty and force of nature. Others revered it as the new religion.)

ROPF members who had bitterly attacked Rodchenko soon began to use his diagonals, tilted views, and close-ups. Rodchenko, in the face of ostracism, began to tone down his work. In spite of all the accusations of disloyalty, Rodchenko's pictures from the midthirties, the socialist realist period, surprise and dazzle the viewer with their sunny affirmation of com-

der the name socialist realism and were tailored to a public that the authorities deemed unsophisticated and gullible. The official formula called for creating an event that reflected socialist dogma and presenting it in a realistic style so that it seemed authentic. Legitimate subjects included happy and heroic peasants and workers, the civic activities of public agencies, and joyous family events—the first day of school, graduations, weddings—all unfolding under the auspices of communist institutions.

Today's Soviet photographers criticize their predecessors harshly for their acceptance of the constraints, and Rodchenko in particular draws fire. During the seventies and early eighties, Rodchenko was a model for a number of Moscow photographers, among them Alexander Lapin. "I worshipped Rodchenko," he says, "until I recently saw an exhibit of his work. I don't know whether it's me who changed, or maybe the time is to blame, but the king appeared to be naked. A total disappointment. His discoveries, those formal findings of his—they are okay, but all are in the realm of form. And what he was doing in the thirties, as it turned out—not only I but others noticed this too—was using his form for Stalin's content. Maybe Rodchenko was earnest about his belief in the party line. But it's nevertheless disconcerting that he so totally embraced and followed Stalinism."

Grigory Shudakov, veteran critic on the staff of *Soviet Foto* magazine, argues against such condemnation. "Photographers had no possibility to shoot the gloomy sides of life because that was considered unpatriotic," he says, "and anyway, newspapers and magazines wouldn't publish such pictures. So they worked on the optimistic side. But they did it very sincerely, being sure they brought to the people interesting, important information."

Did the photographers lack the courage necessary to challenge Stalinist authority? Courage traditionally involves risking a life, joining a battle regardless of the result. But in the Soviet Union, millions died during Stalin's reign, and defiance would have been futile. Under those extreme circumstances, it was courageous simply to endure. But what of the photojournalist's responsibility to be truthful? "This is a serious and complex issue that historians and social scientists must examine," Shudakov says. "It's not that easy."

Russian art has a tradition of serving government that dates from long before the revolution. When Peter the Great decided in the eighteenth century to push a backward Russia into the modern world, he established an academy to control all artistic activity. Modeled on the French Academy of the Arts, it had as its mandate to direct art according to official policy. Since then, style and subject matter have come under the scrutiny of the state.

Had it not been for Lenin's propaganda needs, photojournalism might have escaped this fate. Many photographers viewed the medium as a craft

ARKADY SHAIKHET Textile factory, 1931

belonging to the people, not a fine art to be manipulated by an elite. Even Lunacharsky, who was responsible for Lenin's photography program, believed that every citizen should receive training in photography—a policy that, if executed, would have made state control difficult. Furthermore, as a manifestation of the worldwide anti-art movement of the day, in both photography and film, there was the intriguing prospect of breaking down the barriers between creator and subject, between the individual behind the camera and the one in front of it. Anyone could take either position.

This democratization ran counter to another basic tenet of the Soviet photographers' philosophy—namely that art could and must shape social and political development. With their conviction that artists had a crucial political responsibility, Soviet photographers harnessed themselves to the rulers rather than to the ruled.

So the photographers of the twenties and thirties may not have been aiming at objectivity at all. As creators of icons, they were showing people how to conduct their lives as proletarians and patriots in order to become valid socialists. "Photographers often shot what they would like to see and not what they saw," says Shudakov. "The public accepted these pictures as they accepted sports stars, parades honoring legendary pilots and Arctic

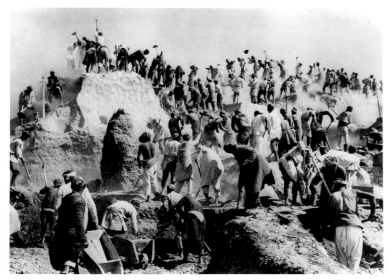

MAX ALPERT Construction of the Fergana Canal, 1939

explorers—as focal points for real expressions of nationalism."

They also made an impact far beyond the borders of the Soviet Union. By the late 1920s and early 1930s, the Soviet approach to photography had inspired socialist agitators in Germany, Hungary, France, Czechoslovakia, and even the United States and Japan. Driven by the conviction that photography could change the world and by the need to mobilize every possible tool for their political struggles, the "worker photographers" movement founded clubs, published magazines, mounted exhibits, and grew to massive proportions by the time of the Great Depression. They made no pretenses about the fact that their goal was not only to inform, but to shape public opinion.

It is no wonder then that in 1931 the first exported Soviet picture story, entitled "Twenty-four Hours in the Life of the Filippov Family," was warmly received in Vienna, Prague, and Berlin. Max Alpert, one of the creators of the story, had been producing picture sequences since the late twenties. In one of his first, he recorded the daily life of a worker who developed from unskilled laborer to trained builder at the Magnitogorsk Steelworks. Such "complete" stories had become staples of the domestic Soviet illustrated press. For "Twenty-four Hours in the Life of the Filippov Family," Alpert, Arkady Shaikhet, and S. Tules of the Soyuzfoto Agency spent four days photographing the Nikolai Filippovs. They produced about eighty pictures, of which fifty-two formed the final story about a metalworker in Moscow's Red Proletarian Metallurgical Plant—his activities on and off the job with his family and friends. The story appeared in the German weekly *Arbeiter Illustrierte Zeitung* (*Worker's Illustrated Newspaper*) and even reached the United States. The picture essay, an art form influenced by film, soon appeared in illustrated magazines everywhere.

The goal of the Filippov story was to provoke Europeans and Americans to observe, from the depths of the Great Depression, the prosperous, or at least comfortable, Filippov family and to draw conclusions about the merits of communism versus capitalism. The Filippovs had work, money to

shop for clothes and food, and leisure activities provided by the Park of Culture and Rest. The story's immense popularity reinforced the Soviet belief in the power of photography.

O n June 22, 1941, out of the blue, or so it seemed to the Russians, the Nazis invaded the USSR. World War II gave Soviet photographers a different and compelling reason to take pictures.

During the first months of uninterrupted horror, the Nazis overran the fertile farmlands of the Ukraine, swarmed into Kiev, and kept up a bloody advance without much challenge from the unprepared Soviets. By September 8, German troops had severed Leningrad from its surroundings. During the icy winter that followed, with no heat, light, or food, thousands of Leningraders died each day from starvation and cold. Though the city was constantly bombarded, the residents remained almost solely preoccupied by their search for food. The siege lasted 900 days, the longest in modern history.

A month after they tightened the noose around Leningrad, the Nazis reached the gates of Moscow. There the Russians managed to stop them, but the horrors didn't cease. In the summer of 1942, grim battles were fought on the southern steppes and along the Volga River, especially in Stalingrad where tanks and hand-to-hand street fighting turned the city into a pile of rubble as well as a symbol of Soviet bravery. In the summer of 1943, the Germans launched an offensive in the Kursk Region, about 200 miles south of Moscow. The Soviets held their ground, but not without suffering another bloody massacre.

By May 9, 1945, the day the Nazis surrendered, at least twenty million Soviets had perished. Every family had been struck. Fathers, brothers, sons, sometimes entire families were wiped out. The war left a staggering social scar that remains even now.

In the period immediately following the Nazi invasion, two million

From the picture story, TWENTY-FOUR HOURS IN THE LIFE OF THE FILIPPOV FAMILY (Nikolai Filippov working at the Red Proletarian Metallurgical Plant), Moscow, 1931

Soviets enlisted in the army. About 200 of them were photographers. They went into the trenches and battlefields. In Leningrad, they photographed the shelling and the bombed-out buildings and the bodies piled in the streets. In Stalingrad, they recorded snipers defending each ruined house and women cleaning up the rubble when the fighting had finished. Outside the cities, they photographed the partisans, the burning villages, and the homeless peasants huddling to keep warm. Dimitri Baltermants, the war's best-known photographer, produced one of its most famous images—relatives searching for their dead scattered about a muddy field near Kerch.

Though most pictures went unpublished, the photographers documented everything: brutality, fear, bravery, and tender moments, too—soldiers tending their wounded, enjoying a joke, receiving letters from

home. They did it with spontaneity and a depth of feeling similar in some ways to the spirit of the revolutionary years. In both periods, the circumstances were exceptional, and the photographers were producing freely and on their own initiative. There may have been a danger of official reprisal against photographers considered to portray the negative, but the need to express the profound experience of this war was greater than any fear of retaliation.

This was true not only of photographers. Squatting in a dugout during the November 1941 battle for Moscow, war correspondent Alexei Surkov wrote a song to his wife that became one of the most popular of the war:

> In our dug-out a log
> fire's aflame...
> Weeping resin, it
> sputters and sighs,
> The accordion's tender
> refrain
> Sings of you and your
> smile and your eyes.
>
> We are now many light
> years apart
> And divided by snow-
> covered steppes.
> Though the road to
> your side is so hard,
> To death's door it's an
> easy four steps.

The authorities criticized the last line as defeatist and bad for morale. Surkov would not rewrite it; he received a letter of support from six soldiers in a

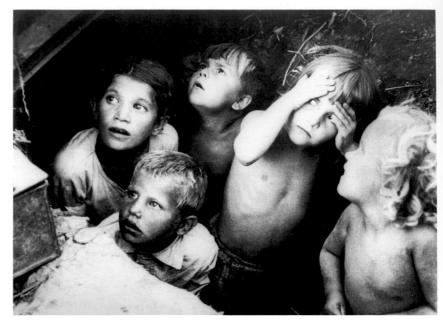

Children in shelter during bombing of Moscow, 1941

Guards tank unit which read, "For them say that death is four thousand English miles away, but for us, leave the song as it is. We have counted the steps it takes to die."

The photographs produced during the war tend to be close-up and matter-of-fact. No special equipment or technique was applied to increase the drama of the images. In this, the war photographers were all alike.

Once the war was over, it was business as usual: socialist realism was back. The burned villages and crumbled cities, the bereaved women and children were ignored by photographers who concentrated instead on a citizenry optimistically engaged in postwar reconstruction. Censorship returned with a vengeance as soon as the battlefields quieted down.

In their yearning for pleasant subjects after the brutality of the war, the Soviets mirrored the mood of the West. In both the USSR and the United States, photography claimed, as it always had, that it impartially recorded the world. But everyone preferred to focus on lighthearted, humdrum aspects.

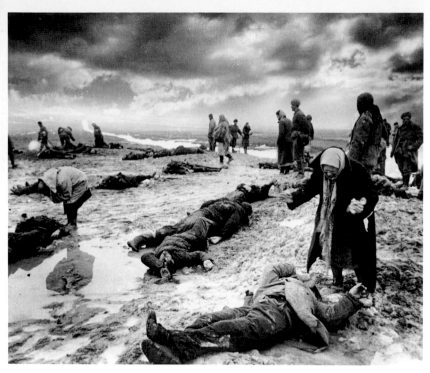

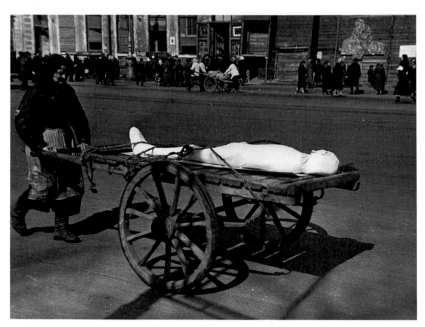

DMITRI BALTERMANTS GRIEF (villagers looking for loved ones after battle), Kerch, 1942

R. MAZELEV Nevsky Prospekt during the Nazi blockade, Leningrad, 1942

Unlike the USSR, America was in a period of economic boom. Though the country had its problems, *Life* magazine reported on Hollywood stars and suburbia. Americans were not yet ready to face the cold war, racial tension, or pollution. To be sure, some objected to the superficiality. Eugene Smith, one of *Life*'s most talented photo-essayists, left the magazine in 1954 to pursue what for him were more meaningful pictures, pictures that would reveal injustice and lead to social change. Swiss-born photographer Robert Frank published his landmark book *The Americans* in 1958. In it, he showed that America included the alienated, the ugly, and the violent.

Frank is one of a growing list of Westerners embraced by today's Soviet photographers, but the one who has stirred the Soviets most deeply is French photographer Henri Cartier-Bresson. He is studied diligently by most of the photographers whose images appear in this collection.

Cartier-Bresson entered the world of Soviet photography shortly after Stalin left it. The dictator's death in 1953 and the 20th Congress of the Communist Party of the USSR three years later loosened the strangle hold of Soviet officialdom over creative life. The personality cult was condemned and the right to diverse opinions endorsed. In photography, a sophisticated amateur movement began to flourish.

In July 1954, Henri Cartier-Bresson arrived in Moscow with his wife after spending eight months applying for visas. Anticipating bureaucratic ordeals that would prevent him from photographing freely, he was relieved to be told that foreigners could photograph everything except the military, railroads, and panoramic views of cities and selected monuments, for which permission was required. In his 1955 book entitled *The People of Moscow*, Cartier-Bresson wrote, "I explained that my main interest is in people and that I would like to see them in the streets, in shops, at work, at play, in every visible aspect of daily life, wherever enough goes on so that I could approach them on tip-toes and take my photographs without disturbing them."

"My photographic methods are not very common in Russia," he went on to write. "Before my trip to Moscow, I had already seen a large number of photographs of Soviet Russia. Yet my first reaction was one of surprise and

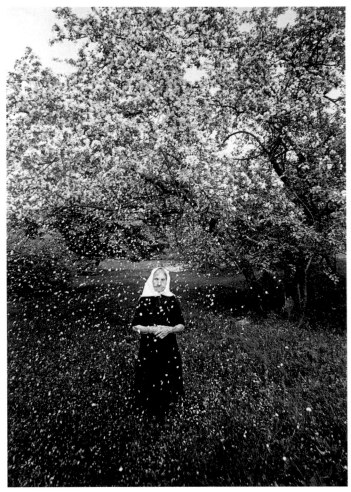

BLOSSOM 12, Lithuania, 1975

the traditional Soviet principle that there is only one orthodox reality and one acceptable viewpoint. Socialist realism expected photographers to be anonymous craftspeople assigned to record facts more skillfully or less, with sophistication or without. In contrast, Cartier-Bresson's photographs taken on Moscow streets and in shopping areas, factories, and subways elude fact. They constitute concrete, almost intimate journals of the daily experiences of ordinary people. There is nothing Soviet about them.

As was typical of a generation of French artists who came of age a decade before World War II, Cartier-Bresson was enchanted as a young man with the French leftist movements that flourished between the wars and repudiated the bourgeoisie into which he was born. He was particularly drawn to the surrealist movement which, among its pursuits, aimed to eradicate the distinction between art and life, an objective shared with Russia's postrevolutionary artists. Surrealist techniques—juxtaposing objects that do not ordinarily belong together, placing an object outside its everyday context—can be compared to Rodchenko's unusual angles and the formalists' call for alienation as an art technique.

Almost forty years after Cartier-Bresson found meaning in the Soviet revolutionary spirit of the twenties, the tables have turned. Soviets from a diversity of backgrounds, philosophical outlooks, and geographical locations are now profoundly inspired by Cartier-Bresson. They yearn to seize a telling moment, Cartier-Bresson style, from the flux of life and to achieve his visual excellence and freedom to make a personal statement.

discovery....I tried to capture a straightforward image of the people of Moscow going about their daily life, to catch them in their ordinary acts and human relationships."

He left his mark on the young Soviet photographers he encountered. Remembering those days, Moscow photojournalist Leonid Bergoltsev described an experiment in which, under Cartier-Bresson's influence, ten photographers went to shoot the same subject—one of the city's railroad stations. They returned with vastly different pictures. "Ten people have ten points of view; each sees in his own way," Bergoltsev said. This challenged

Real innovation in Soviet photography emerged in the 1960s from a surprising quarter—the Baltic republics. Lithuania had a photographic tradition going back to at least 1919, when its university established one of the first photography departments in Europe. In those years, Lithuania and its two sister republics, Estonia and Latvia, each tiny independent states, influenced the flourishing revolutionary avant-garde art of their huge eastern

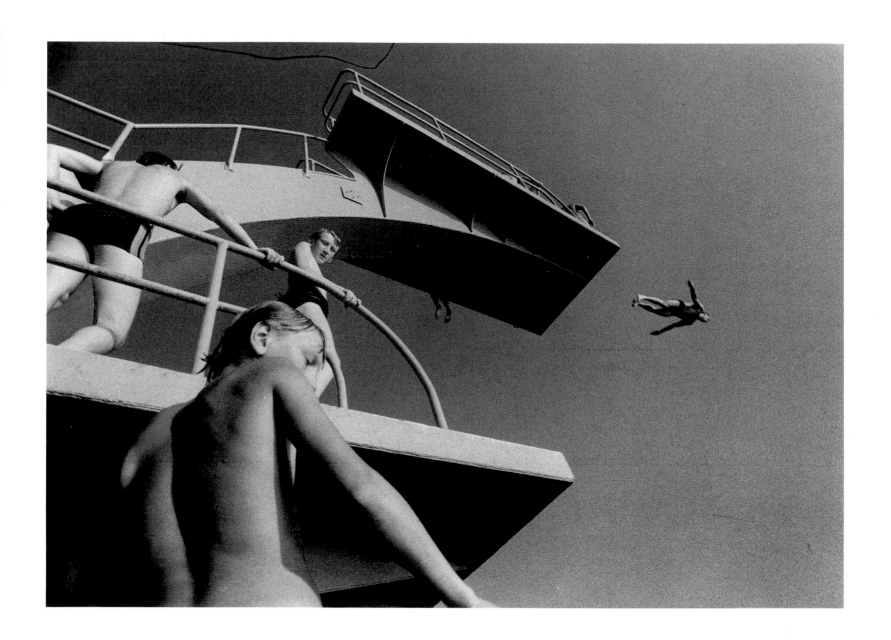

VIRGILIJUS ŠONTA
A FLIGHT
Lithuania, 1980

neighbor. But independence in the Baltic countries lasted only during the brief span between the world wars.

Within two decades of their country's being annexed to the USSR at the end of World War II, a group of Lithuanian photographers began to record everyday Lithuanian life instead of the prescribed monumental Soviet projects in science and technology. Their goal was to raise national consciousness and capture the quality of Lithuanian culture, particularly its simple humanness. They meant to create photographic art through reportage, to select ordinary objects and events and record them aesthetically. Rural life was the primary focus, derived from the romantic portrayal of

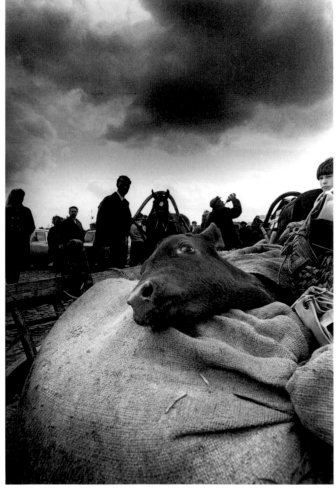

ALEKSANDRAS MACIJAUSKAS From the series, IN THE MARKET, no. 107, Lithuania, 1975

country life in Lithuanian literature. While their subject matter and aesthetic approach ran counter to approved Soviet policy on photography, their optimism regarding the human condition was officially acceptable.

At first, these renegade photographers produced images of idealized villages and townscapes, lined elderly faces, and Lithuanian holidays and seasons. Romualdas Rakauskas, an outstanding member of this romantic sixties group, is usually represented by his series entitled "Blossoming," which poetically portrays the coming of the Lithuanian spring. In that northern climate, where spring means rebirth after the cold, isolating winter, Rakauskas chose a subject that would allow him the greatest opportunity for lyric exultation. His people, bathed in falling petals or carrying delicate bouquets, seem like fantasies.

By the late sixties, Lithuanian photographers portrayed the people in a more down-to-earth fashion. The pictures gained in depth and subtlety. Romualdas Požerskis, in his series "Lithuanian Old Cities," mingles people with the very stones of their neighborhoods. His subjects mourn and work and mind their children. Sometimes they long to escape their gray environment; at other times, they seem to be extensions of the old city blocks.

In his series "Country Celebrations," Požerskis' characters act out personal dramas at holiday time in moments of escape from daily routine. His theme of individual psychology revealed during leisure was shared by a number of Lithuanian photographers. So was his emphasis on the people's link to their homeland. In Algimantas Kunčius' country scenes, the landscape and those upon it are always in tune. We sense the particular personality of the Lithuanian people and the texture of the place that nurtured and shaped them.

Aleksandras Macijauskas extended the romantic ideology of the sixties to include more gritty aspects. His work overflows with vitality and chaos. Contained within his picture frame are animals, machines, household articles, and, of course, people bursting with life. His market series, photographed between 1969 and 1984, is his most extensive project. The markets

are not simply commercial exchanges; they are social gatherings full of human stories. Like a number of other Lithuanian photographers, Macijauskas uses wide-angle lenses which enable him to combine portraiture with context or to assemble several vignettes within a single picture frame. Often Macijauskas crouches for a low angle that projects the commotion of the foreground against a serene background sky, turning an ethnographic picture into a stage where a mysterious drama of life is played out.

In his series on veterinary clinics, Macijauskas' wide angles enable him to gain distance and manipulate the emphasis and significance of his subjects. He separates animals from their handlers and combines the toughness or pain of a situation with his positive view of humankind. Through the char-

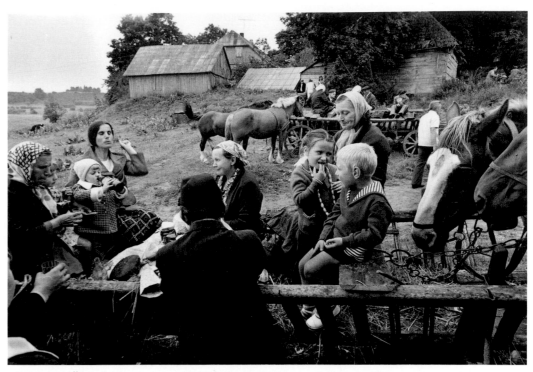

ROMUALDAS POŽERSKIS From the series, COUNTRY CELEBRATIONS, no. 39, Lithuania, 1976

acters and their settings in the markets and veterinary clinics, and in his "Dying Trees" series and other work, Macijauskas tells us that life's essence is to resist destruction: this is the strength of a tree, and of society and the individual as well.

Lithuanian photography is changing in the 1980s and 1990s. The rural theme is being replaced by urban life. Photographers have dispensed with the idea that human character is most accurately revealed during leisure time, so festivals and public events are photographed less frequently. Unrestrained idealism no longer characterizes the photography. There is an effort to broaden the earlier concept of beauty based on pristine nature, to find beauty in other contexts. Entering the factory, Lithuanian photographers search for the harmony between human beings and machines. They have little interest in machine design or the dark side of industrialization. They remain faithful to their optimistic humanism.

In the early part of the 1980s, a new generation of Lithuanian photographers turned away from reportage altogether. They wanted to portray what to their minds was the absolute essence of truth. They could count on the realness of physical objects, a table for example, but not on nostalgic village scenes. Form and composition became crucial. Perhaps the young Lithuanians were drawn to the work of Estonian and Latvian photographers. Though there is a similarity of outlook among the three Baltic groups, Latvian images are gentler on the whole, and somewhat more abstract. Estonian pictures tend to be the most abstract of all. Arguments raged among the Lithuanians on the nature of photography and its mission. But the photographers reconciled eventually, all accepting the value of diversity and multiplicity.

Through the years, the Baltic photographers' ability to organize has been key to their success. Their saga began in 1969, when a group of young

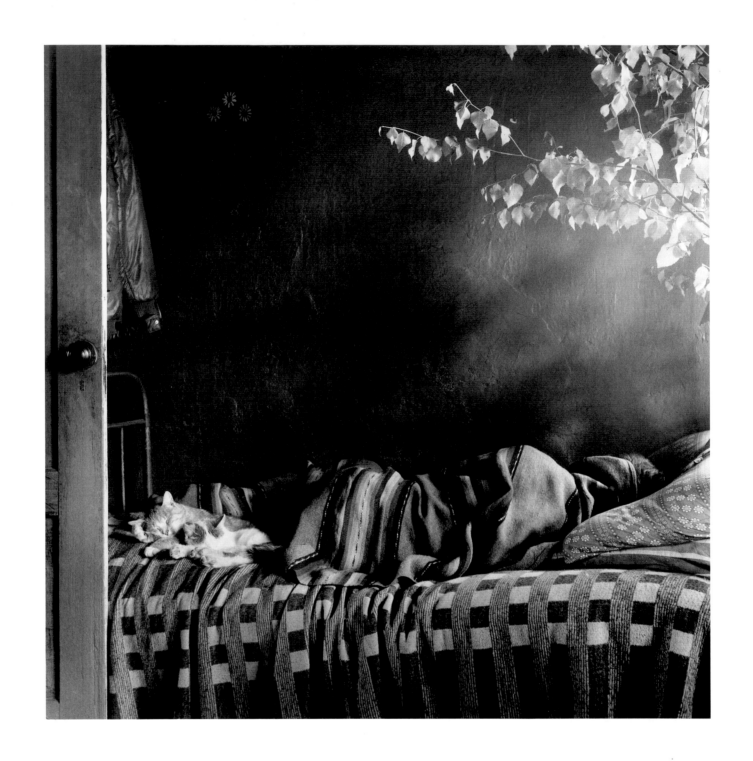

INTA RUKA
From collection, MY COUNTRY PEOPLE
Balvi, Latvia, 1986

Lithuanian photo artists exhibited in Moscow to great acclaim. They subsequently managed to obtain state support to form the Society for Creative Photography of the Lithuanian Soviet Socialist Republic (LSSR). This was an amazing achievement. Until as recently as 1989, other Soviet photographers were not allowed to organize on their own. They only were permitted membership in the photography section of the Union of Journalists of the USSR or in amateur clubs. The Lithuanian society, unique in that it is self-supporting through commercial activities, furnishes a home for photography as an art form. It offers galleries to hang fine photography in the republic's seven largest towns and provides darkrooms, classes which are quickly filled, and financial support allowing the best photographers to live from their work.

Every year photographers gather for ten days in Nida, a retreat on a sliver of land jutting into the Baltic Sea. Everyone brings work, exhibits are mounted, talks are delivered. Soviet photographers from other republics are invited for an exchange of ideas.

The Baltic photographers have had an immense impact on photographers and critics throughout the Soviet Union. Grigory Shudakov, a critic for *Soviet Foto* magazine, is mystified by the Baltic phenomenon. "The rise of Baltic photography is an enigma," he says. "It is impossible to answer the question, why in the Baltics and not in Leningrad or Moscow? But Baltic photography is not homogeneous. Lithuanian photography is one thing; Latvian photography is quite another. What we consider to be the Lithuanian school of photography pertained to social problems. It attempted to comprehend reality philosophically through reportage. Whereas in Latvia, there developed first-class portrait photography—aesthetic, exquisite, fine compositions, more finished. I think what stimulated all this was a high general level of culture in the Baltics, and also some national characteristics, but it is difficult to name their sources."

Shudakov tries to explain the Baltic phenomenon as part of a general Soviet phenomenon as well. "We have strong photography in recent years in

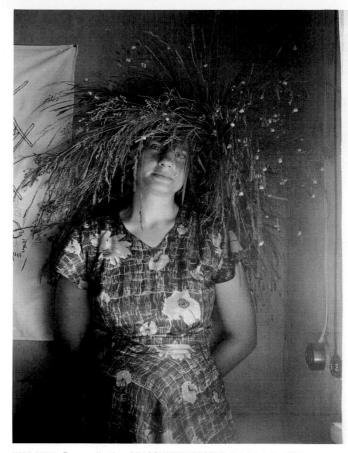

INTA RUKA From collection, MY COUNTRY PEOPLE, Balvi, Latvia, 1985

Armenia, in Georgia, in Leningrad. We even have quite a number of very strong photographers in the Urals—Chelyabinsk for example," he says. But while some of this photography is interesting, on the whole it unquestionably lacks the power of Baltic photography.

Moscow photographer Sergei Gitman says that Baltic photography "became famous because of its technical and aesthetic superiority. And the photographers have enjoyed special status as the first to establish an organization blessed by the authorities. They played an important role as an inspiration and guide to photographers outside the Baltic states. In fact, some Muscovites found out about each other through the Baltic society." But Gitman maintains that the Baltic photographers "keep to themselves on the whole. They don't often invite outsiders to exhibit there. A few years ago Moscow photographers couldn't gain recognition from Moscow authorities

VYTAUTAS BALČYTIS A PLACE FOR GAMES, Vilnius, 1987

Tasma photography club of Kazan, recalled that "during the years of stagnation, I was saved by photography. Writers like Sinyavsky and Nekrasov were expelled from the country, but nothing like that was done to photographers. So photography was the single accessible means for expressing myself. In a world of lies, it was enough for me just to go to a store, buy film, and create something, and not depend on the printing presses and politics. This was true not only for me, but for others, too."

During this time, photographers were preoccupied with forbidden topics. Poverty, drunkenness, alienation, prisons, old-age homes, psychiatric wards—it was imperative to show all. Familiar subjects, when shown, were portrayed a different way. Heroic workers now looked tired. Sometimes they seemed lost, desolate, or disoriented, placed at the edge of the image instead of front and center. Isolation and loneliness became central themes.

Cycles or picture stories were preferred over the single image. Moscow photographer Vladimir Vyatkin believes that "the job of the photographer is very close to the job of the playwright. Photography has its roots in the laws of drama. The visual sequence is the most complex, difficult way to produce, but also the most intelligent and authentic." Photographic storytelling grew out of Russian literary traditions and harkened back to the Soviet photography of the twenties and thirties. In this regard, many Soviet photographers part paths with Henri Cartier-Bresson, who was never a storyteller, who always managed to fully have his say in a single image.

A number of outstanding photographic cycles were produced during the seventies. Ljalja Kuznetsova's ethnographic series on gypsies, photographed late in the decade, documents the hard lives of these vagabonds of the Tatar steppes. Despite their poverty, the people are beautiful, and their land is wild and romantic. Though her subject matter is unconventional and her approach personal, Kuznetsova's images project a very Soviet sense of optimism.

Also in the late seventies, Vladimir Siomin photographed the construction of the Baikal-Amur Railroad (BAM). Rejecting the celebratory heroism

or from the photo group in Lithuania." Gitman admits that the Baltic photographers simply had another, different mission. They needed to separate themselves from the Soviet mainstream. It therefore remained for other Soviet photographers to discover their own path.

A new Soviet photography began to develop, not in the 1980s era of glasnost as one might expect, but during the stagnation of the 1970s, in the Brezhnev years when ideology began to fall apart. State institutions were no longer vital or even viable. The photography establishment, always an arm of the government, was not free or fit to give voice to the mood of the country. Losing faith in the leadership and the system, intellectuals and uneducated workers alike were turning inward to their own private lives. For those who cared about their country, it was a time of despair.

Then the amateur photography movement came alive. So-called amateur photographers were those who had entered the field from other professions such as engineering, mathematics, and physics. Through their images of everyday life, they expressed their personal frustrations and simultaneously reflected the outlook of the times. Valeri Pavlov, a member of the

of traditional Soviet photojournalism, he captured commonplace moments that reveal his subjects' lives. A quiet, introverted quality about Siomin's pictures gives them a mysterious spirituality. His later photographs of the aftermath of the Armenian earthquake also pick up details and seemingly arbitrary moments, this time to bring powerfully home the horror and immensity of the tragedy.

Yuri Rybtchinski, originally a word journalist, photographed provincial life with gritty realism, a courageous act during those years of Brezhnevian illusions. In his photo series entitled "Small Town," his pictures of Cheropovitz in the Vologda Region are grainy and coarse, just like the life he depicts. On assignment for the Novosti Press Agency in 1978, he photographed a forced labor colony. He managed to produce sterile official pictures alongside images representing his own views, but by the end of the seventies, he felt he could no longer work for the official press.

A few talented photographers did thrive inside the Brezhnev establishment. "It is a mistake to suggest that during the times of stagnation nothing of worth was published. Some good things were done," says Vladimir Vyatkin, an accomplished press photographer. "Don't confuse the time of stagnation with Stalinism."

Some photographers of the 1970s who worked for the press sincerely embraced the establishment viewpoint. "A publisher sets a task for me," Vyatkin says, "an ideological task—not simply to show life in an institution, but to show that life there is good. I know what the publisher wants and how to photograph it." Vyatkin honestly believes that such a job does not entail manipulation of reality. "I love my people, my country—that's why very often I can't make myself shoot what we call the negative side of life."

Vyatkin believes in his work, and today's changes in the ground rules complicate things for him. "My photography has changed for the worse in recent years," he says. "When I was young, I shot what I wanted, from my heart. During the times we call the period of stagnation, I learned who will buy what. But even then I developed themes, undertook trips, and generated projects in addition to my assignments. As a rule, my awards and prizes are for those projects which I developed myself. Nowadays, much is spoken about the necessity of perestroika, restructuring, and I don't know how to apply it to myself."

The Russian word for dissident translates as "one who thinks differently." In the seventies, the dissidents' opposition did not take the form of a unified antiestablishment plan of action. Instead, it was a matter of living according to personal principles, of doing what each individual conscience would allow. The dissidents' challenge was one of quiet noncooperation.

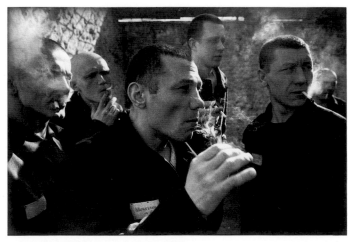

VLADIMIR VYATKIN Prison, Vladimir, 1988

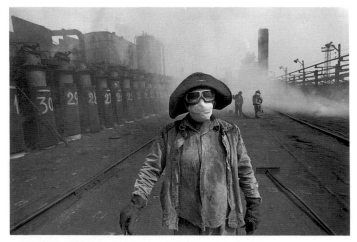

ALEXANDER TROFIMOV Industrial worker, Novokuznetsk, 1980

Had it been more aggressive, they might have been destroyed. This nonco-operation was not a negative phenomenon, however. Though physically the photographers withdrew, spiritually they were activists revitalizing the culture.

By the end of the seventies, Soviet photography began to take new directions. The photographic subculture has now branched into a network that links Vilnius to Moscow, and Moscow to Kazan, Novokuznetsk, and Chernovtsy. Its members concern themselves with the approaches of Soviet

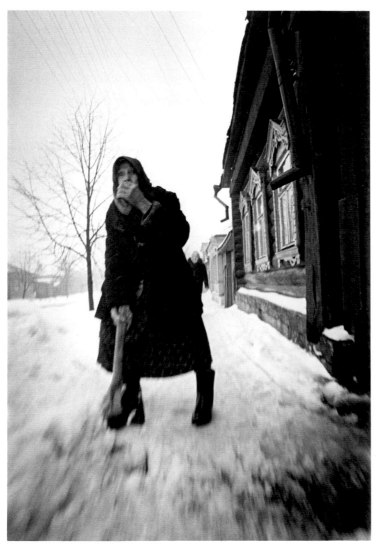

YURI RYBTCHINSKI From the series, TOWN, Borovsk, Kaluga Region, 1980

photographers in the twenties and with the most up-to-date trends in the West. This new photography does not reject social documentary; on the contrary, it takes a step forward in apprehending reality.

There is tension today between the amateur photographers gaining in recognition and the professional photojournalists. In the Soviet Union, amateur means underground, outside the press establishment, without legal status. The definition of professional is press employee. No connection exists between professional status and photographic ability.

Art photography is distinguished from photojournalism, and the artists are the amateurs. Some overlap; a few of today's press photographers were yesterday's amateurs, and occasionally a press employee chooses to leave his job and take the status of amateur. Once in a while, photographers straddle the categories, producing personal work during off hours.

A parallel can be drawn between the two branches of current Soviet photography and the Oktiabr and ROPF movements of the late twenties; the amateurs can be compared to the formalists and the press photographers to the documentarians. But the comparison carried too far is misleading. Oktiabr's experimentation in form was in the government's service, whereas today's amateurs devote themselves wholeheartedly to the portrayal of real-ity. Some art photographers consider themselves more worthy of the label documentary photographer than their counterparts, the photojournalists, who record what the government assigns. Art photographer Alexander Lapin says, "When it was totally impossible to expose the truth, there were those who worked officially and those who turned down official work and photographed only for themselves, putting their pictures in a drawer. In those days, my criterion of quality was the following: if one of my photos was published in the Soviet press, it was a poor photo. It was too banal, too untruthful, or too optimistic."

Photojournalist Leonid Bergoltsev, disputing the artists' claim to a monopoly on truth, complains that they "dwell in their own minds too much. They distort what God made instead of recording reality." Both

amateur and press photographers believe their mission is to chronicle objective facts.

But for amateurs, the task of exposing less visible truths and the effort to get photography recognized as an art form have been almost as important as recording hard facts. The art-versus-document argument was fought on an entirely different stage early in this century in the United States, when Alfred Stieglitz repudiated the definition of photography as "merely" documentation in order to promote it as an art form. The dispute has never been completely resolved. Yale professor and photography critic Alan Trachtenberg, writing in 1989, attempts to put the issue to rest when he says, "Art and document are arbitrary terms that describe a way of looking at photographs rather than qualities intrinsic to them." Composition and content mean different things in different times and contexts.

In any case, the proclivity of Soviet officialdom to blur the distinction between the ideal and the real has imbued the new nonestablishment photographers with a passion for factuality. Their highest goal is to see clearly and to reveal what they see in their photographs.

Present-day Soviet photographers have a score to settle with the past. In making the link between the photograph and reality a basic question, they are challenging past representations. By examining the relationship between picture and truth, the photographers are forced to think of their own role differently. The photographer of the past was a craftsperson hired to deliver a specific product. The new photographer is an artist with unique vision, and that vision must be acknowledged in the search for truth.

Like their disillusioned countrymen of the Brezhnev years, the new photographers turn inward. Instead of documenting public works, their photographs record physical objects and individual human experience. Ironically, social themes occupy a central place in these personal photographs. In searching for reality, photographers have found a new language for social reporting.

All Soviet photographers, even those who call themselves artists, have their roots in documentary photography. Most feel their cameras should be employed in the service of society. "When life gets better, we'll shoot pictures of other things," says a Kazan photographer. "Now we must address the shortcomings that interfere with our lives."

The thoughtful photographers of the 1980s and 1990s do not approve of those who merely wish to expose the defects in their society. "That, in my mind, is dangerous and wrong," says Alexander Lapin. "It is a dead end. We must take into consideration the causes, the reasons behind our situation. Something positive must be found, and for this, time is needed."

"Simply to shoot rubbish heaps, people who live in misery, is very easy," says Vladimir Vyatkin. "All you have to do is take a camera with a motor drive, close your eyes, and shoot in every direction. It is more difficult to get at the causes of our problems or to shoot good material on the positive side of our life."

In their search for truth, the new photographers are redefining reality. At the same time, they are creating art—realities that exist only as photographs. Alexander Lapin explains that "the goal is a sort of combination of beauty and truth. One cannot exist without the other."

The photographers of the eighties have each groped toward a personal style. Vladimir Filonov, concerned with the impending disappearance of Russian village life, has created a series entitled "Journey Into the Heart of the Country." In Tolstoyan tradition, he carefully recorded the everyday details of village life and raised them to the level of symbols. More than a report on the decay of a Russian community, the series is a wistful portrait of the village of yesterday.

After completing her early series on gypsies, Ljalja Kuznetsova continued to examine individuals contained within social structures of one kind or another. Her series called "The Circus," photographed in 1984, pictures performers behind the scenes, practicing their acts or interacting with family and colleagues. The performers are neither glamorous nor young, but they exhibit strength and dignity. Kuznetsova's series entitled "Women," photo-

graphed between 1982 and 1984, contrasts the bleak conditions of the Soviet woman's life with her femininity and individual character.

A number of the new photographers have focused their efforts on a single geographic location. Moscow is the subject of Alexander Lapin's photography. Exquisitely composed, his pictures record the city's harshness and its poetry, the coldness and indifference of its streets and institutions, and the warmth and wit, and often the alienation and loneliness, of its people. Many of his photographs, he says, are "formed on the ground of a paradox: outwardly ugly aspects of life expressed with photographic form that is beautiful. For me, this equals music." Lapin does not produce picture series. A devoted student of Cartier-Bresson, he sees each photograph as an individual work of art. "My goal," says Lapin, "is to make one shot that will cause a revolt in the soul."

Alexander Trofimov began his career as a welder in Novokuznetsk. Later, as a photographer, he became deeply concerned about pollution in his hometown and produced a series of images documenting the damage wrought by factories on workers and the environment. In the summer of 1989, Trofimov's images were exhibited, along with the work of concerned Novokuznetsk painters and sculptors, in an old church converted to a gallery on Razina Street just outside the Kremlin wall. Photography exhibited with other art forms is still a rare phenomenon in the Soviet Union.

Current Western subjects and styles have made an impact on the work of several Soviet photographers. Igor Moukhin, young and a new arrival on the scene, began producing photos of subcultures, punks, rock fans, and street artists in the mid-1980s. His images are strong, well designed, and fresh. Lately, he has begun to turn his camera and his eye to the lives of ordinary working people.

Boris Savelev, photographing city dwellers and their environments in Leningrad and Moscow, is one of the few Soviet photographers working in color. The geometric abstractions and unexpected combinations in his 1988

VLADIMIR FILONOV From the series, JOURNEY INTO THE HEART OF THE COUNTRY, Village of Pogoreloye, Kostroma Region, 1989

book entitled *Secret City* exhibit the influence of Western styles. In 1987, he and photographer Elena Darikovich discovered American photographer Alex Webb's book *Hot Light/Half Made Worlds* at the Moscow Book Fair. Savelev, appreciating the graphic qualities and the mystery of Webb's images, excitedly recognized an intellectual and visual kinship.

Though Soviets like Savelev, Moukhin, and Lapin scrutinize Western photography for inspiration, Western technology, cultural experience, and social needs are vastly different from their own. Soviet and Western photography are thoroughly dissimilar as well.

In the West, the camera is everywhere. The abundance of images means photography must be increasingly sensational to maintain the impact, to make the viewer shudder with pain or pleasure. The pressure to make something new is relentless. In this environment, contemplative photographers like

Elena Darikovich and the poetic Tarnovetski, who find barely discernable beauty in commonplace scenes, and meticulous documentarians like Eduard Gladkov, who photographed "The Village of Tchachnitsy and All Its People," would be swallowed up.

Today's Soviet photographers are examining reality from a political standpoint, while Western investigations in recent years are mostly technological. Soviet photographers want to use their photography in a moral way to expose political failures and fulfill the photograph's potential to improve the world. Westerners look back over a century of socially concerned photography and feel that it accomplished little. In the West, new electronic systems enabling photographers to manipulate photographs more drastically than socialist realists could have imagined force viewers to ask from a physical rather than a political perspective if a picture is real.

Soviet photojournalism and photo art have never been entirely separate, whereas in the West, photojournalism and art photography parted paths years ago. Grigory Shudakov of *Soviet Foto* magazine explains the Soviet situation when he says, "Our entire photographic heritage and legacy is our social and documentary photography. The best of it is art photography in its attention to form, composition, and light." This is beginning to change only now. Boris Mikhailov, Roman Pyatkov, and a handful of others have turned away from documentary work. They call themselves "soc-artists" and appropriate elements of socialist realism for satirical purposes to expose the hollowness and cruelty of past illusions.

In the West, photojournalism and photo art rarely meet. Western photojournalists, like their colleagues everywhere, diligently report on news-breaking events. They produce more graphically stunning information faster than ever before and with increasing technical sophistication. For today's Western art photographers, invention, not representation, is the goal. The artists manipulate the photograph's believability for their own ends, to make the language of public information communicate their personal experiences or to reflect on current social fictions. Furthermore, today's Western artists

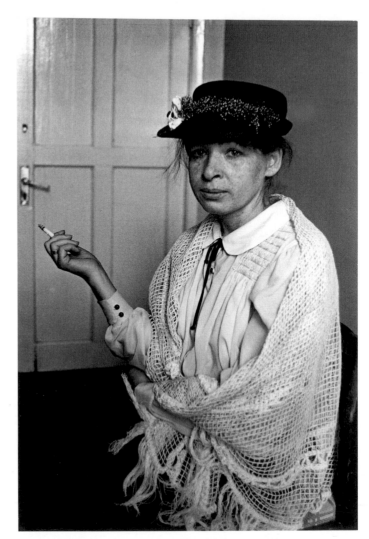

LJALJA KUZNETSOVA From the series, ON WOMAN, Kazan, 1983

believe the medium, by its nature, is an accomplice in creating fiction. Soviet photographers have a deep faith in photography and attempt to replace political fiction with photographic fact.

Soviet photographers prize their newly undertaken task as truth bearers. For the Soviet photo artist, the photographer is the subject just as much as the elements in the image. The very fact that the image belongs to the photographer, not to the state, contributes to its value. Many of today's Western art photographers challenge the central role of the photographer.

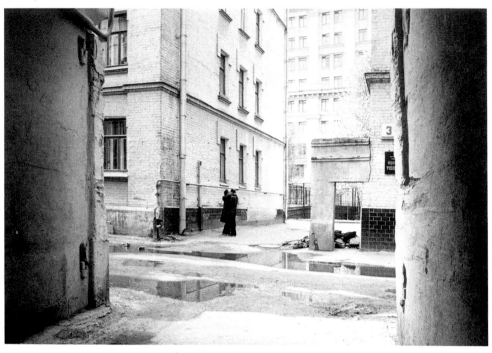

ALEXANDER LAPIN A KISS, Moscow, 1983

have done in color can touch my black and white." Vadim Gippenreiter, quoting his stepfather who pursued photography as a hobby, warns against relying on fancy lenses. "A good photographer can take pictures even with a glass button," he says.

In East and West, mainstream photographers give concrete expression to each society's values, demonstrating what is good and worth striving for. They present us with role models—in the USSR, proletarians and patriots working for the motherland, in the United States, consumers exhibiting youth and beauty and surrounded by products. As Sergei Gitman put it, "One group sells grape juice, the other valiant labor."

But there are differences in form as well as content. Form is primary in the Western image; the basis of the image is visual. Finnish media researcher Hannu Eerikainen explains, "In Western culture, sensuality determines ideas, while in Eastern culture, ideas determine sensuality...the West has the eye as metaphor, the East the word." Perhaps this flows from the fact that, by and large, Westerners have an empirical view of existence while Easterners understand life through universal principles. Although the new Soviet photographers are increasingly interested in form, intellectual content and documentation still come first. The way Yuri Rybtchinski sees it, "Westerners are concerned with the visual perfection of the print—the sharpness, the composition. Russians don't care about technique, only about content."

Soviet photographers, then, clearly do not embrace everything Western. Alexander Lapin reflects the typical viewpoint when he says, "There are things I do not care for in the West—mass culture, hundreds of photographic magazines, surrealism, kitsch, gimmickry. It's a shame all this exists."

But by giving the public a choice, Westerners create an audience capable of viewing photography with at least a basic understanding. In this era

Using various techniques, among them that of appropriation—integrating someone else's existing images into a new work—the photo artist questions the originality of the photographer and makes a statement about the loss of authenticity in modern life.

Soviet and Western photographers have differing views about the craft of photography and about what constitutes photographic art. Many of the new Western art photographers were trained in painting, sculpture, or even literature. They are proficient in their use of technology, but do not care much about the traditional craft of photography. Freed from both fact and technique, they invent their own worlds. The Soviet photographer, deprived of advanced technology, cares intensely about the craft and worries that new devices threaten it. In the West, technology has finally transformed color photography into art, but Soviet photographer Ljalja Kuznetsova, like the majority of her colleagues, does not think highly of color. "Black and white is true photography," she says. "It has more possibilities than color. Nothing I

of glasnost and democracy, Soviet photographers are concerned not only with official policy, but also with public taste. It used to be that the government bestowed immortality on selected art and then disseminated it to the vast population. The people were removed from the selection process, rendering them unable to make critical judgments. Kazan photographer Shamil Bashirov says, "The uneducated viewer is a problem for us. For many years, the viewer was indoctrinated, fed closed publications. Art photography meant nice portraits or tiny thoughts one millimeter long. Now no one is against the new. Everyone wants something fresh, but when it appears, everyone is scared." It is no different in cosmopolitan Moscow, says Sergei Gitman, who works there: "The entire public, from the uneducated to the intellectual elite, wants upbeat messages—simple, direct, illustrative."

Because legitimacy in the Soviet Union, when obtainable, can only be bestowed by officially sanctioned organizations, unsanctioned or amateur photography always had difficulty finding an outlet at best, and was condemned as unpatriotic at worst. However, the amateur label, which implies that the work does not deserve close scrutiny, often protected unsanctioned photography from condemnation. Amateur groups serving this function have flourished intermittently throughout the Soviet Union since photography was introduced. Leningrad's twenty-year-old Mirror Club, Tbilisi's Point of View Club with only five members, and Tasma, named for a brand of photographic paper produced in Kazan, have united photographers devoted to social themes and realism.

Amateur status finally changed in the summer of 1989, when the Moscow Union of Photo-Artists was formed with official blessing. This independent group will belong to a federation of unions, one from each republic. The idea is to formalize ties among those not working for the press. Supplementing the new geographical network will be a society called the Union of Moscow Photographers that links photographers of diverse professional interests: newspaper photographers, fashion and applied photographers, critics and historians, and avant-garde and art photographers. Starting with 150 people at the end of 1989, membership is expected to grow rapidly.

Changes in the Soviet political situation and permission to organize have presented photographers with unimagined opportunities, but the altered cultural climate makes taking advantage of them complicated. Whether by political necessity or due to a deeply rooted cultural phenomenon, the Soviets have refined a sharp skill for reading between the lines. This tension between what is on the surface and what is hidden lends sophistication and subtlety to Soviet literature and art. The new goal to reveal everything presents the Soviet artist with a real challenge.

But the Soviet photographer has a rich heritage on which to fall back. National characteristics show up in images that follow the tradition of Russian literature, looking deeply into human passions and emotions. They appear in pictures by Boris Smelov which capture a feeling of foreboding, of being in a city of shadows and mystery—a Russian feeling. Russian sensibility also derives from the timeless Russian condition, that of suffering. "A satisfied person cannot understand a hungry one," says Shudakov. "An artist's soul always aches," adds Kazan photographer Shamil Bashirov. "Another's pain is like his own." Perhaps it is suffering that gives the Russians their mystical and spiritual depth.

Alexander Lapin says, "This may be brave, but I'll try to define the uniqueness of Russian photography: it is characterized by a strength of spirituality and humanism. The spirituality is a fundamental Christian quality. Those who possess it, even if they are not believers, have goals of kindness."

Lapin quotes a Russian proverb: "'A talent is like a pimple; you never know where it will erupt.' Talented people are born irrespective of conditions—in your country, in ours, in China. People themselves don't know what they are capable of, and that's terrible. Soviet society has provided talented artists with false models and aims, and now I hope we have the chance to change this."

Leah Bendavid-Val

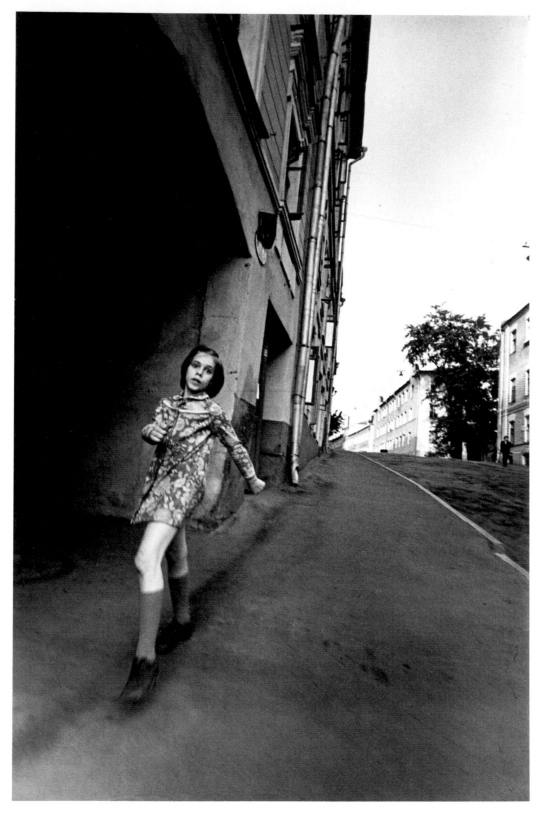

YURI RYBTCHINSKI
GIRL IN AN ALLEY
Moscow, 1985

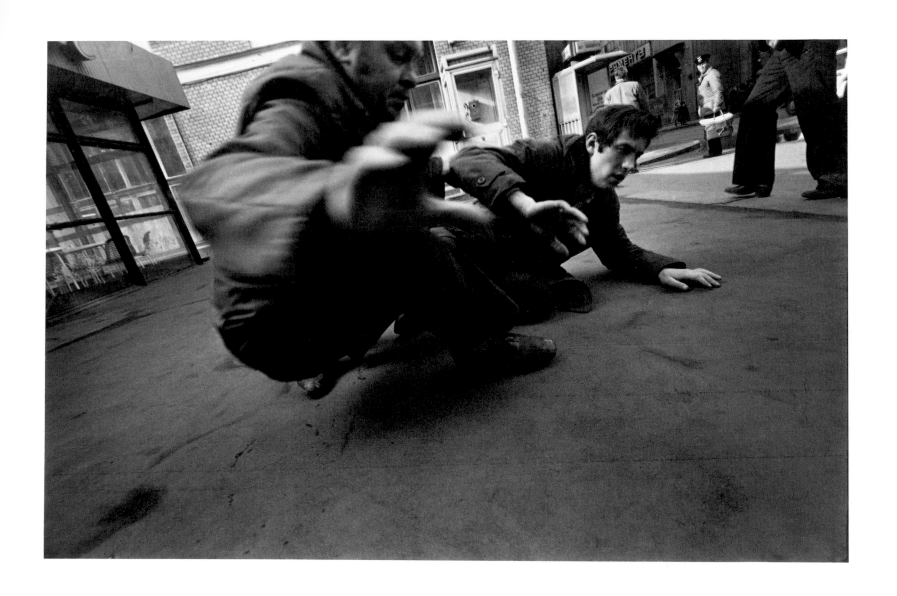

YURI RYBTCHINSKI
Drunkards on Moscow street
Moscow, 1987

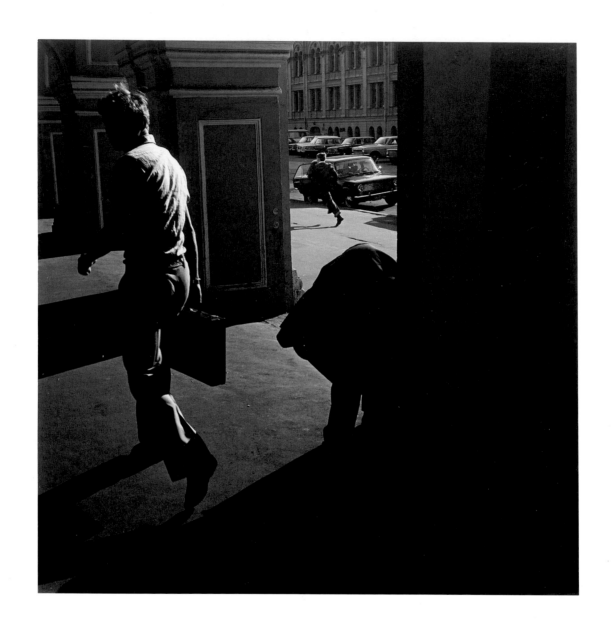

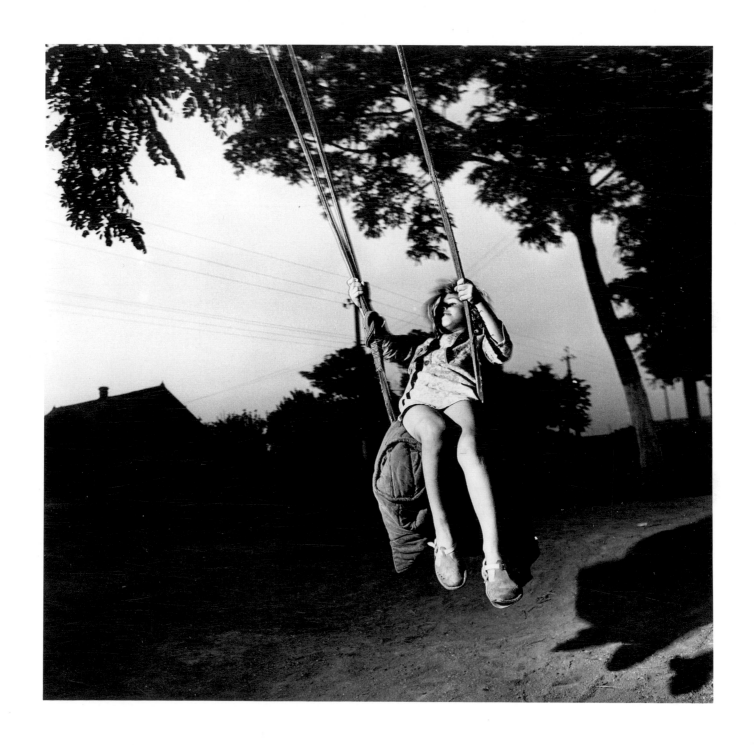

NIKOLAI KULEBIAKIN
Untitled
Ukraine, 1983

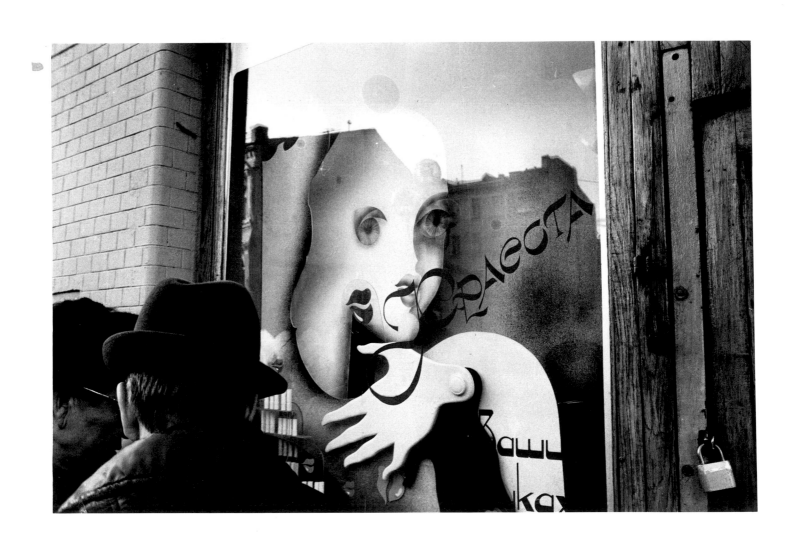

SERGEI GITMAN
ARBAT STREET (shop
window sign reads "Beauty")
Moscow, 1989

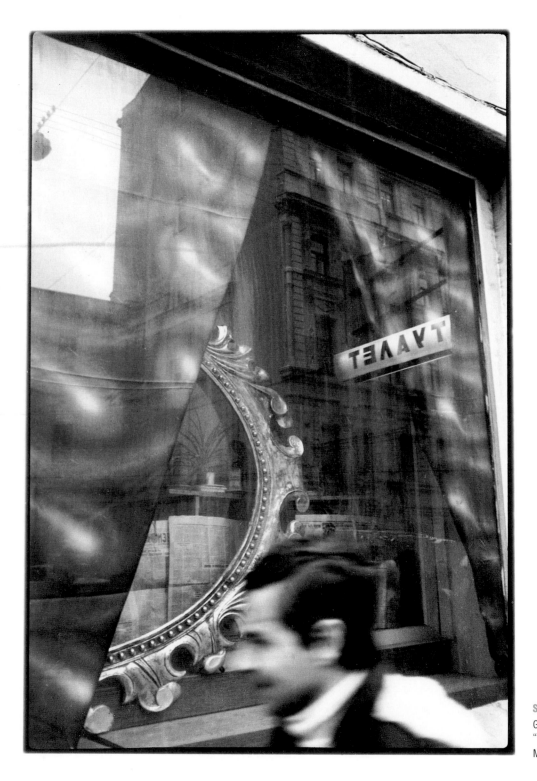

SERGEI GITMAN
GORKY STREET (sign for
"Toilet" reflected in window)
Moscow, 1989

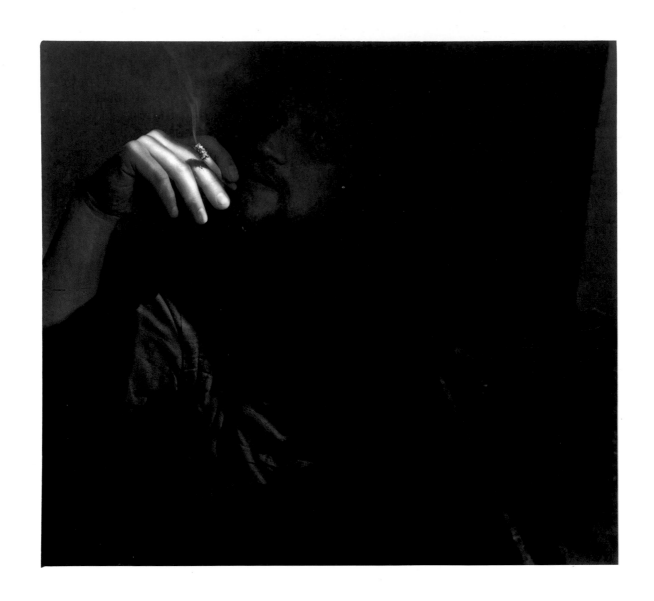

ELENA DARIKOVICH
Boris Savelev
Moscow, 1986

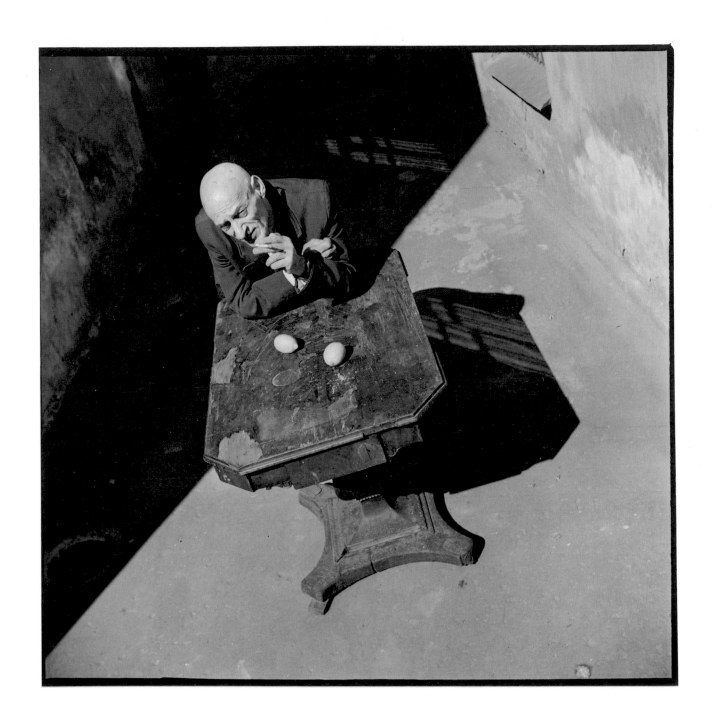

BORIS SMELOV
LYUBITEL KISLOGO ("lover of sour things")
Leningrad, 1973

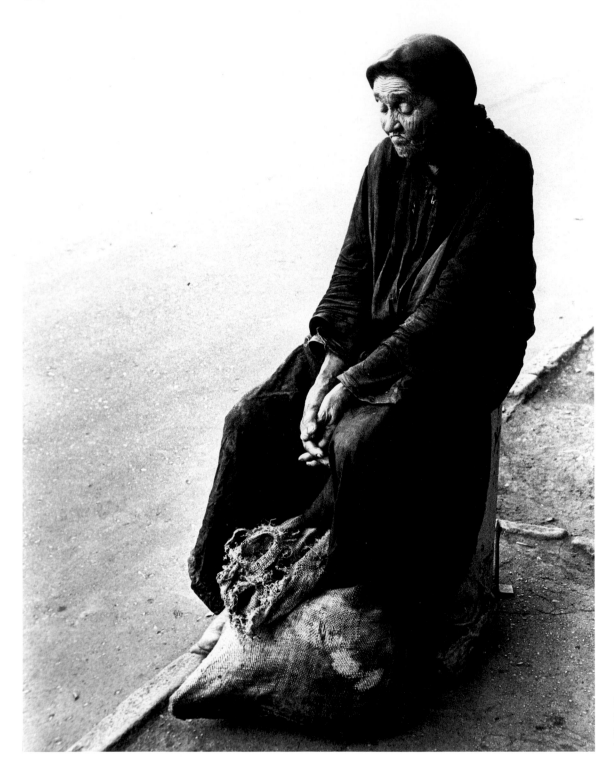

MICHAIL NASBERG
WOMAN ON THE
STREET
Tbilisi, Georgia, 1983

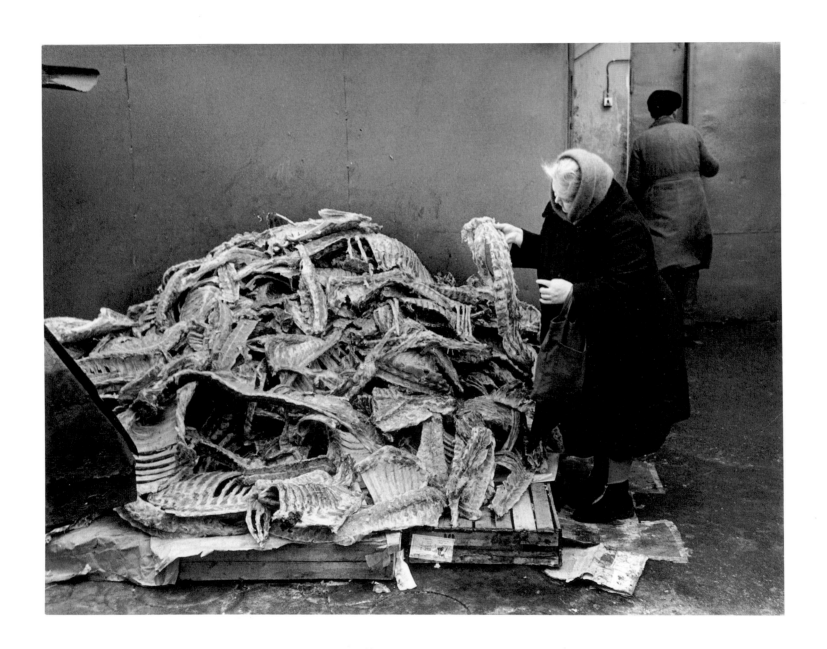

GENNADI BODROV
MEAT? (store next door to
photographer's flat)
Kursk, February 1989

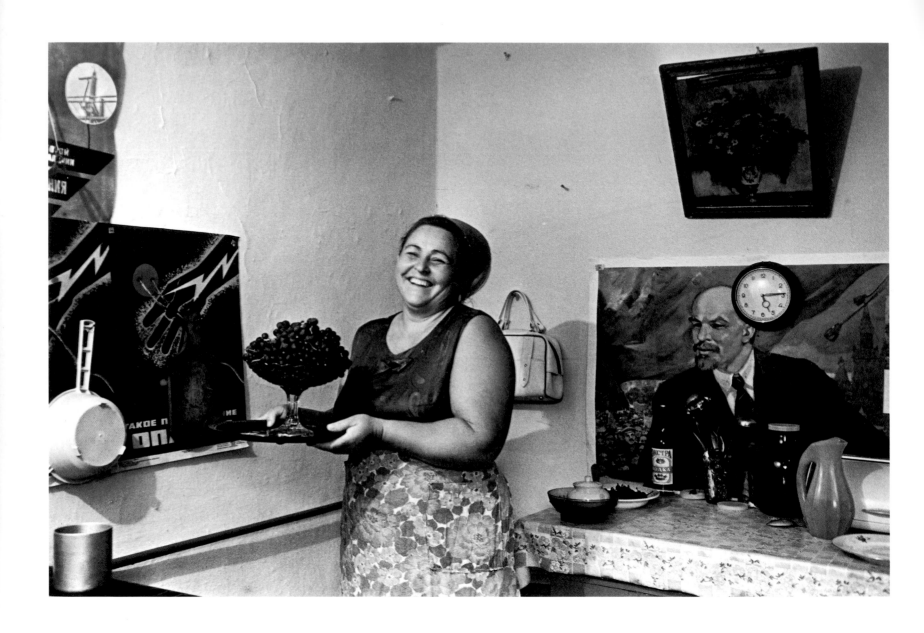

YURI RYBTCHINSKI
Village kitchen
Kuban, 1976

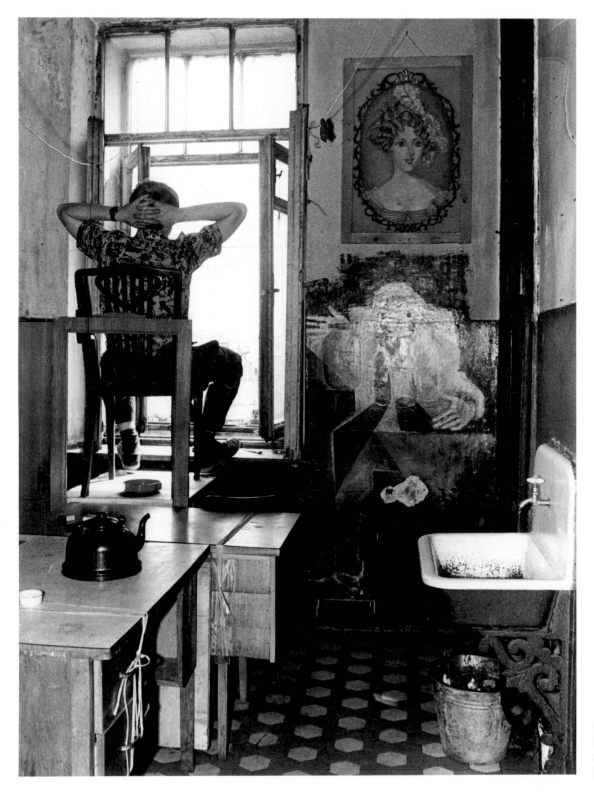

VASILI SHAPOSHNIKOV
NOSTALGIA, THE OLD
ARBAT
Moscow, 1989

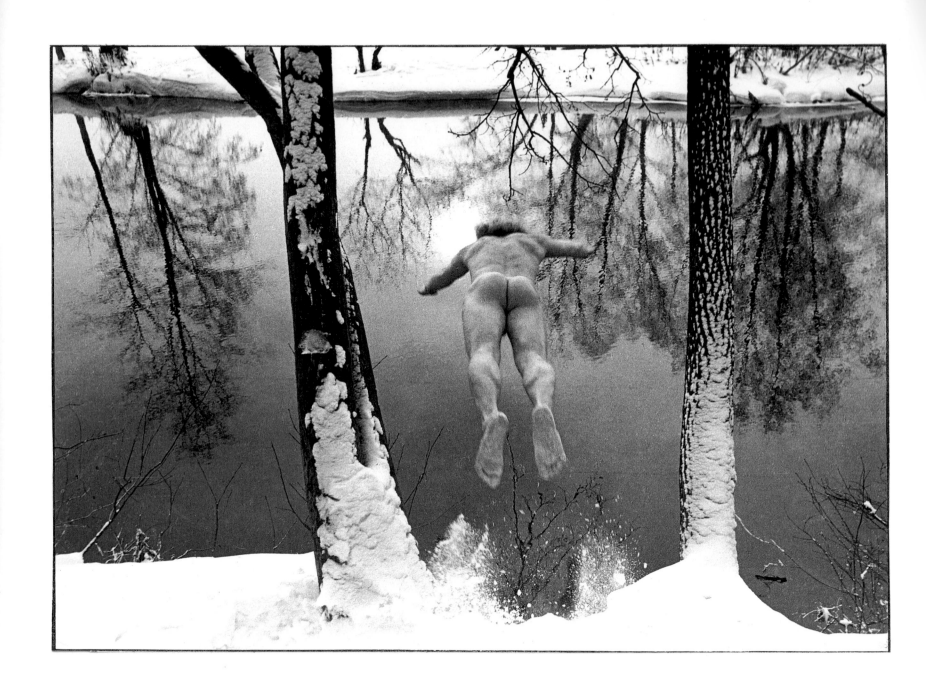

VALERI MIKHAILOV
THE LEAP
Village of Scherbakovka near Kazan, 1981

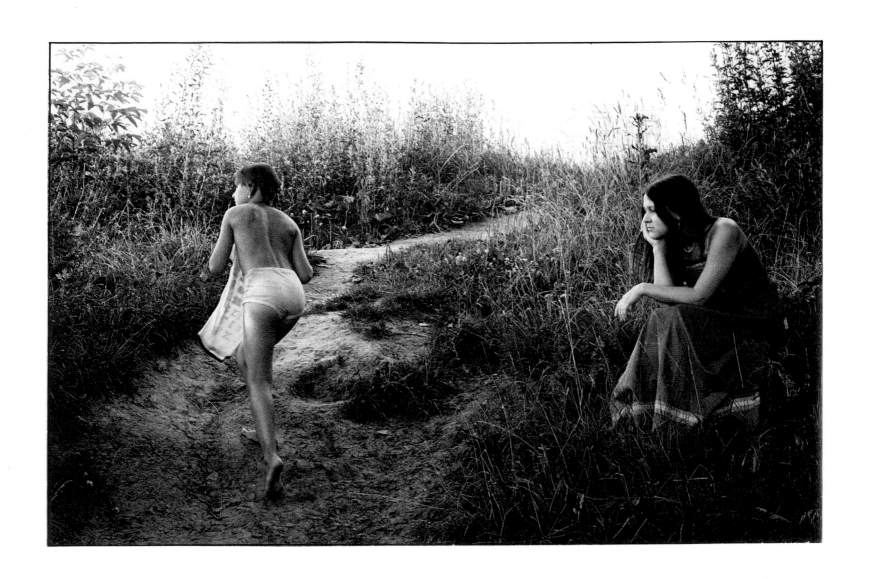

ALEXANDER LAPIN
IN SUMMER
Moscow, 1983

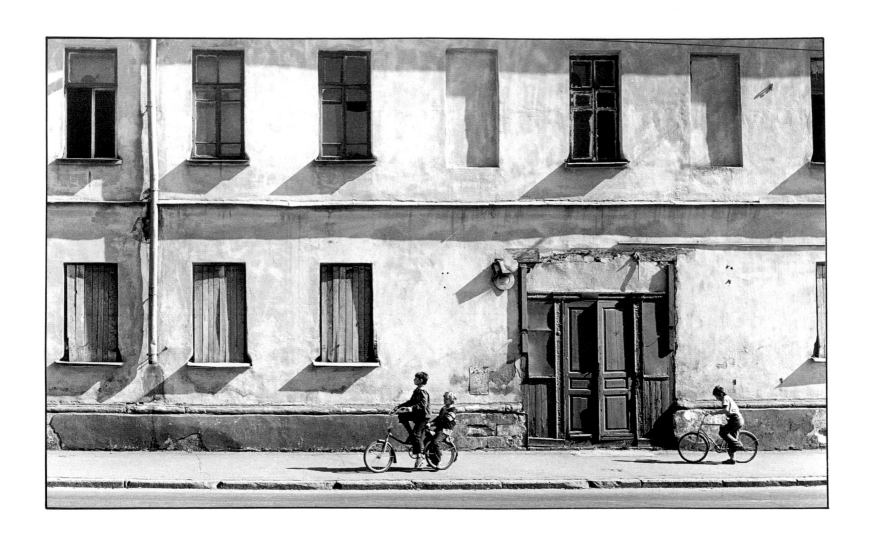

ALEXANDER LAPIN
TWO BICYCLES
Moscow, 1987

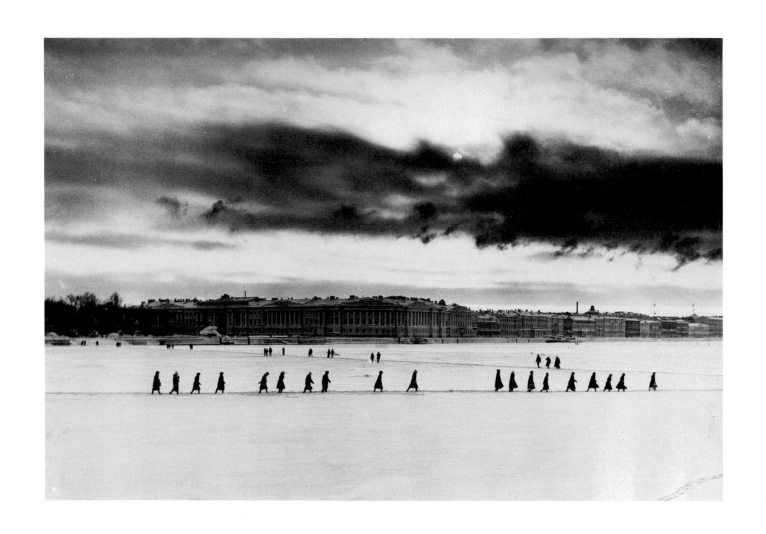

SERGEI KOROLJOV
Neva River
Leningrad, 1987

BORIS SMELOV
MAN WITH A HATCHET (AFTER RASKOLNIKOV)
Leningrad, 1975

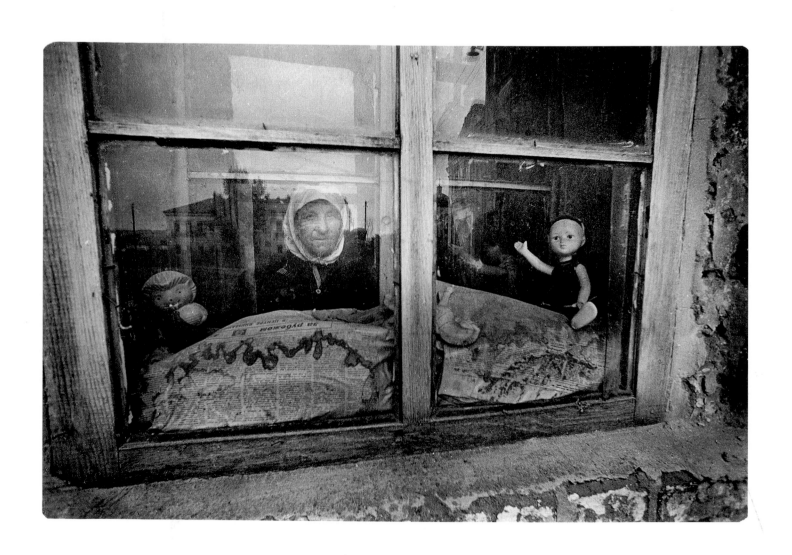

VLADIMIR FILONOV
WINDOWS
Skanov Monastery, Penza Region, 1987

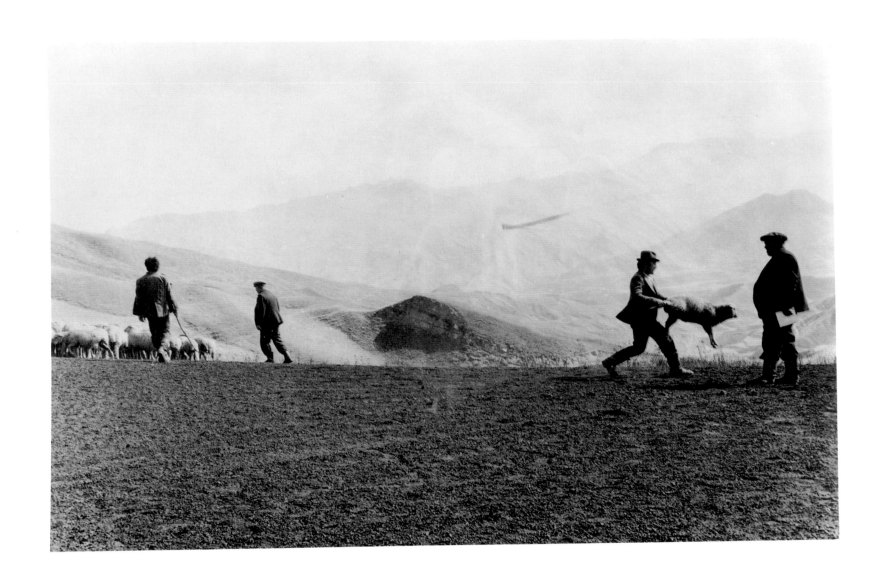

VLADIMIR SIOMIN
Counting sheep herd
Village of Kumukh, Dagestan, October 1987

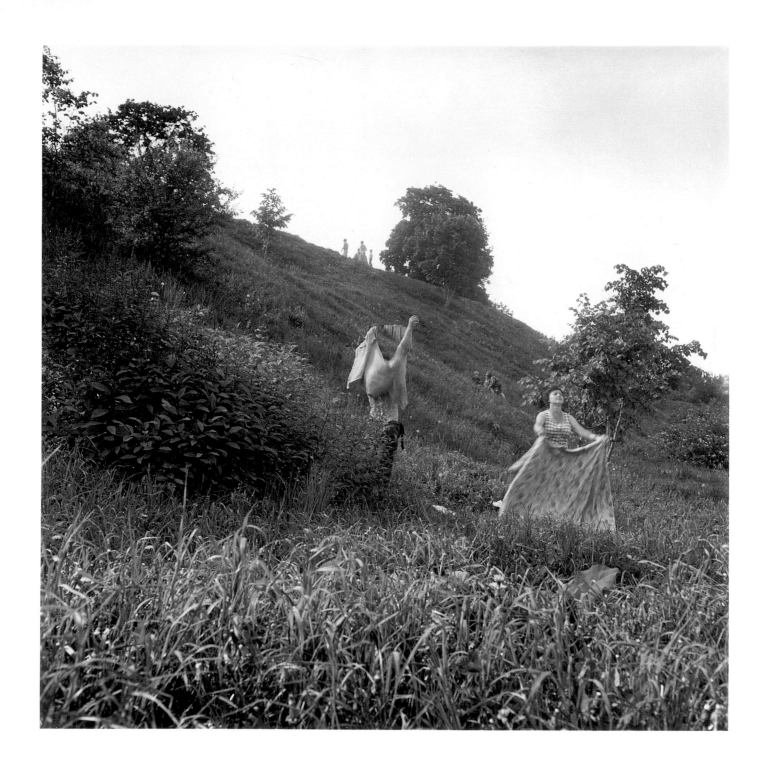

VYATCHESLAV TARNOVETSKI
Untitled
Moscow, 1989

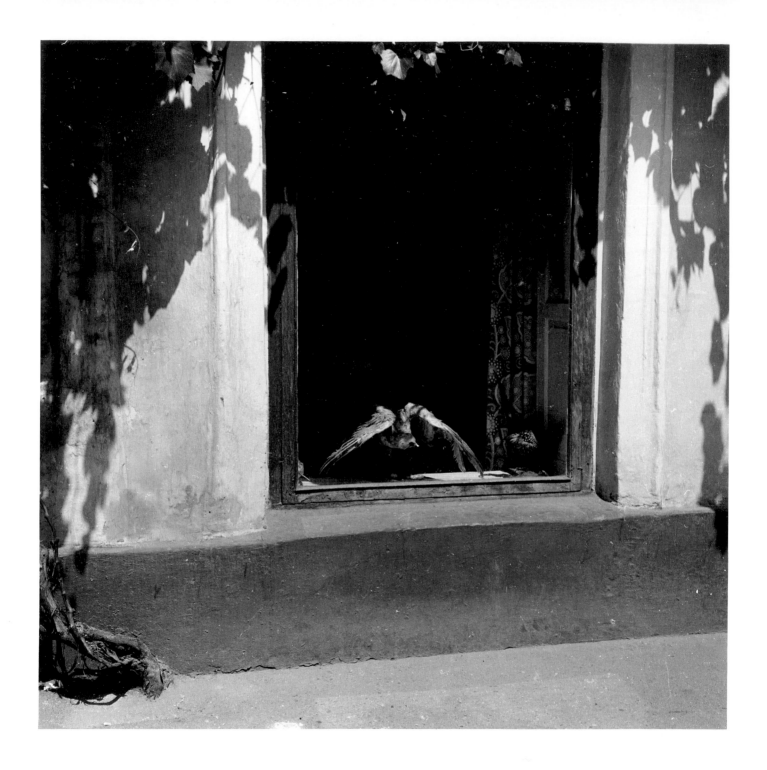

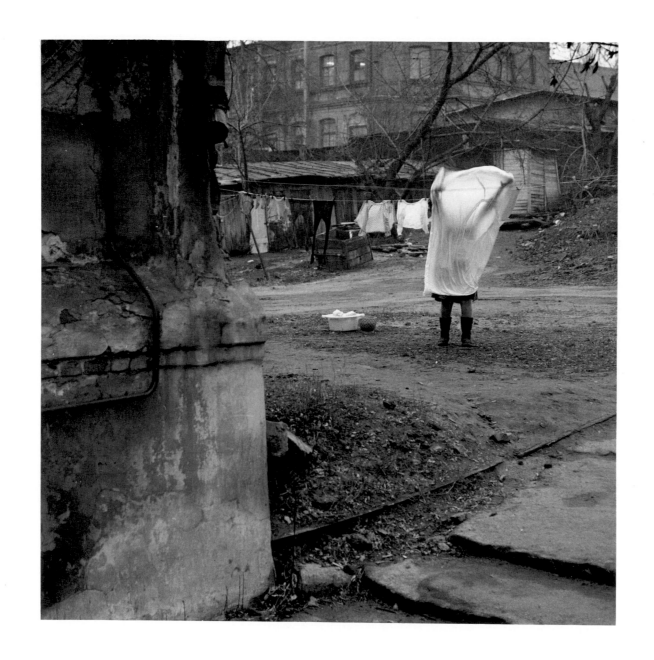

GENNADI BODROV
WASHING
Kursk, 1984

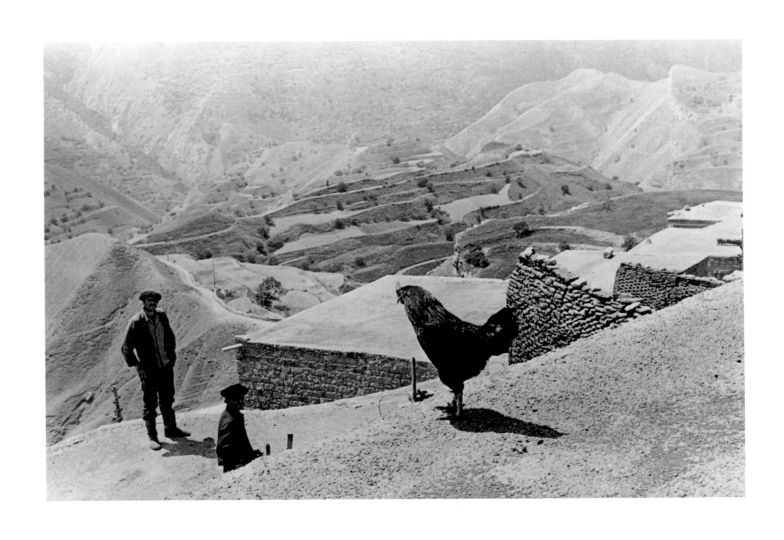

VLADIMIR SIOMIN
PULSE OF LIFE (ALMOST OUTSIDE TIME)
Village of Chokh, Dagestan, 1985

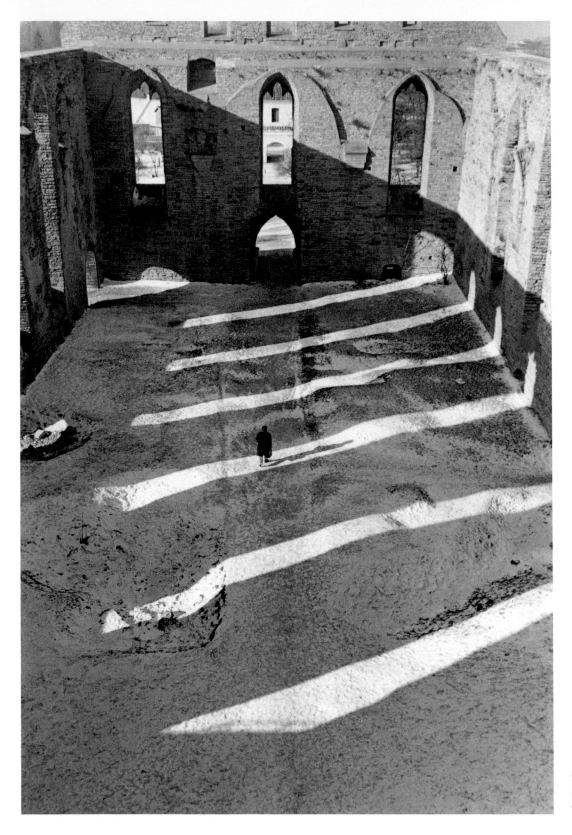

VLADIMIR SIOMIN
Church ruins
Tallinn, Estonia, April 1980

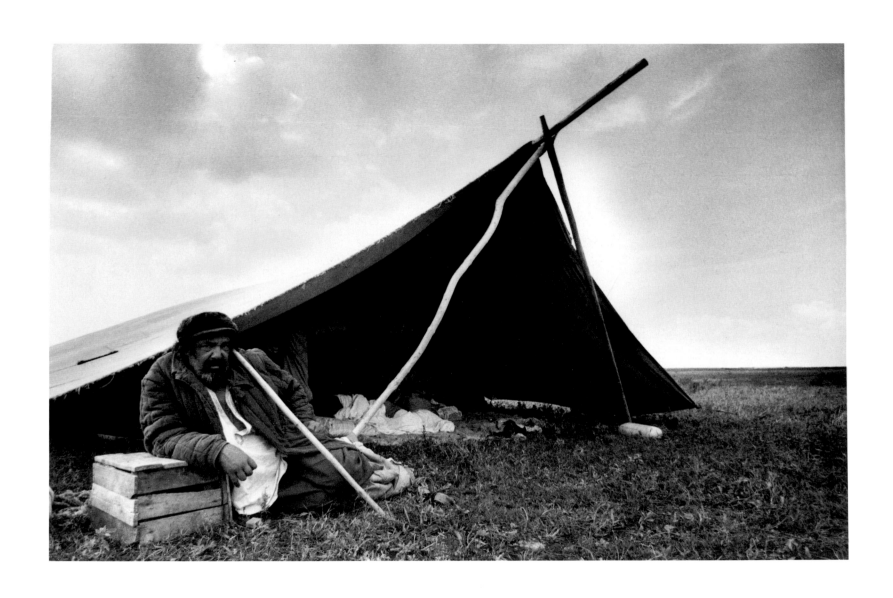

LJALJA KUZNETSOVA
From the series, GYPSIES
Uralsk, 1979

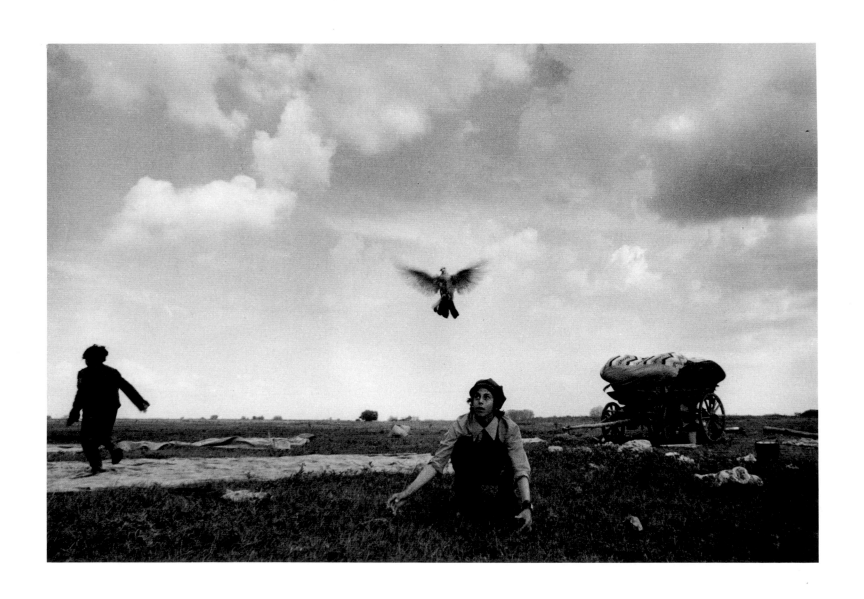

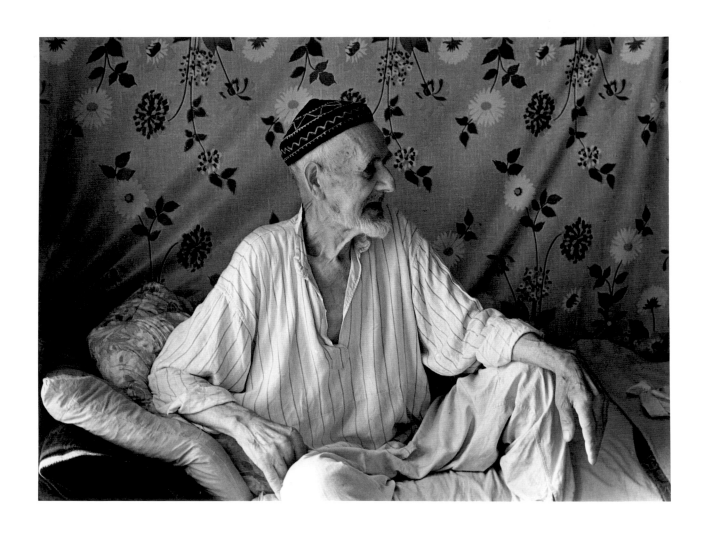

RIFKHAT YAKUPOV
From the series, DISAPPEARING VILLAGE
Kazan, 1990

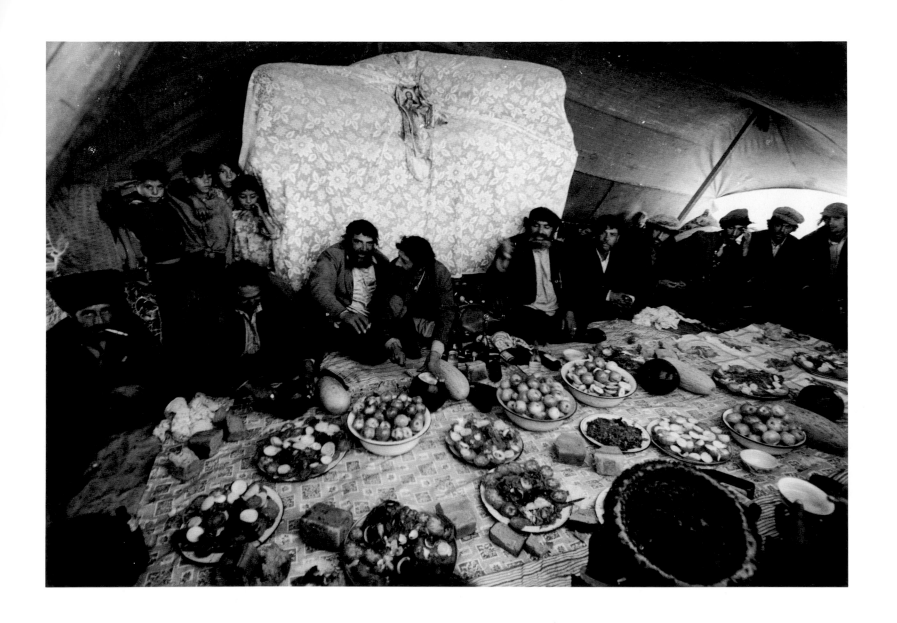

LJALJA KUZNETSOVA
From the series, GYPSIES
Uralsk, 1979

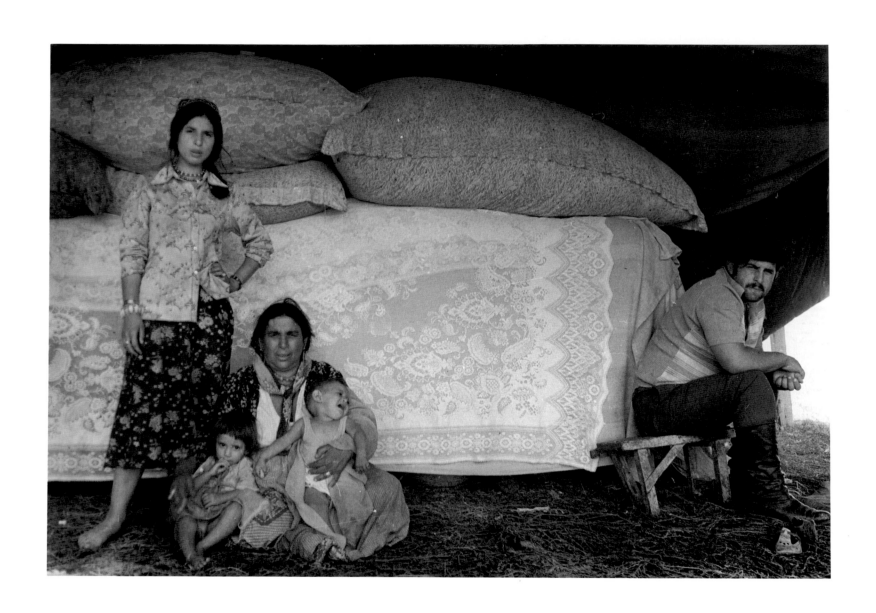

LJALJA KUZNETSOVA
From the series, GYPSIES
Uralsk, 1981

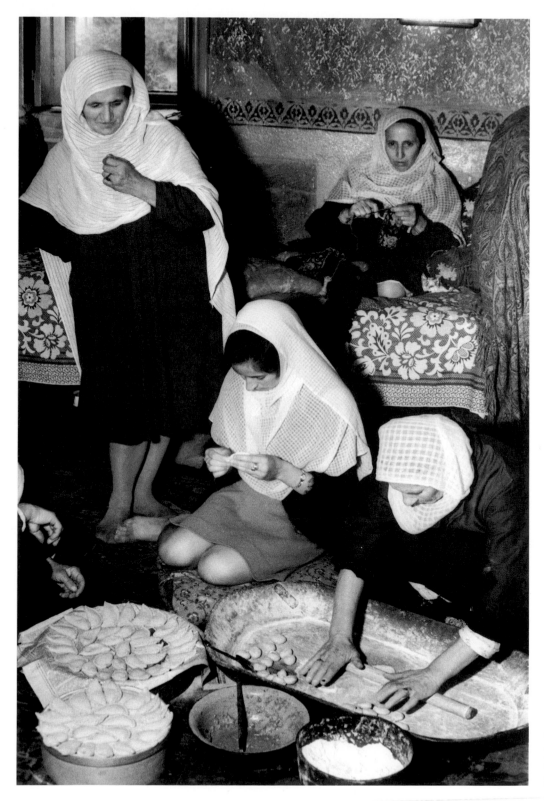

VLADIMIR SIOMIN
Preparing food
Village of Kubachi,
Caucasus, May 1989

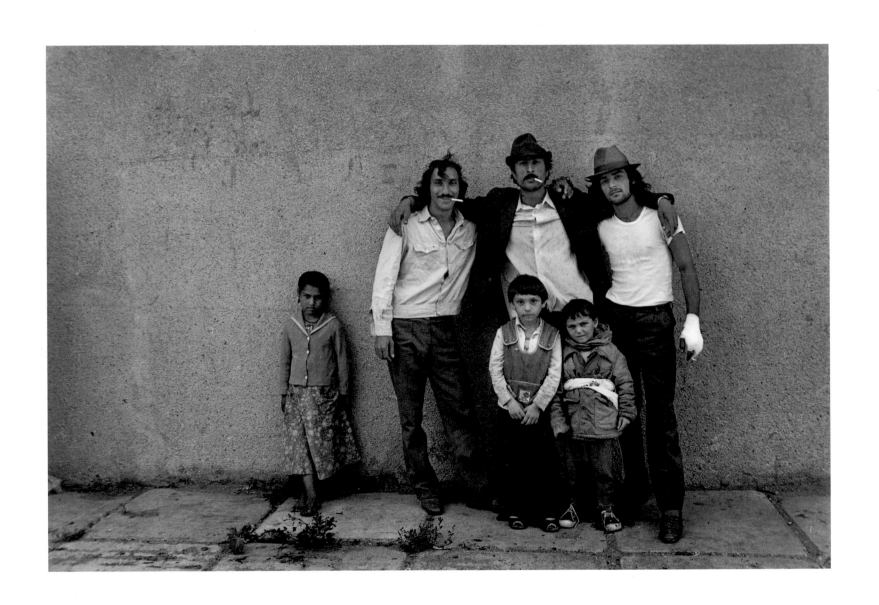

LJALJA KUZNETSOVA
GYPSIES
Odessa, 1990

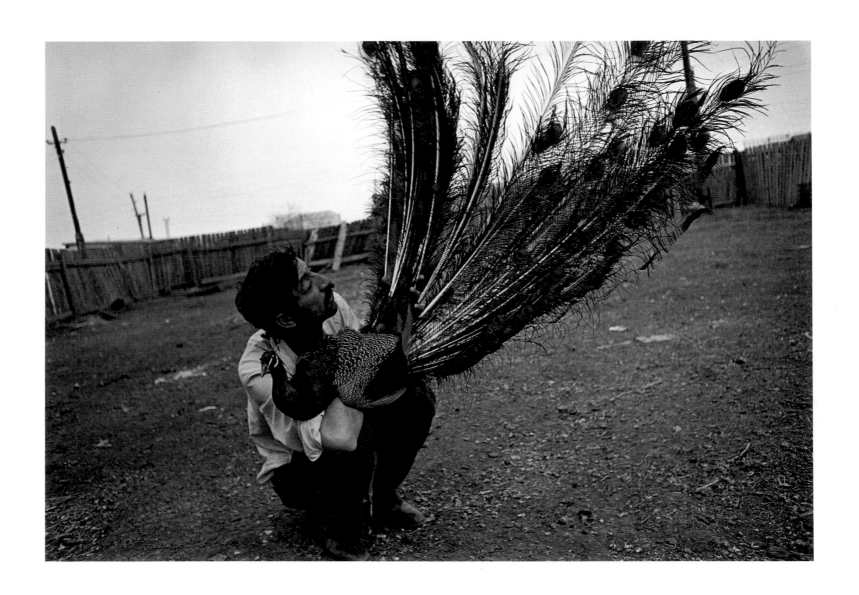

LJALJA KUZNETSOVA
GYPSIES
Odessa, 1990

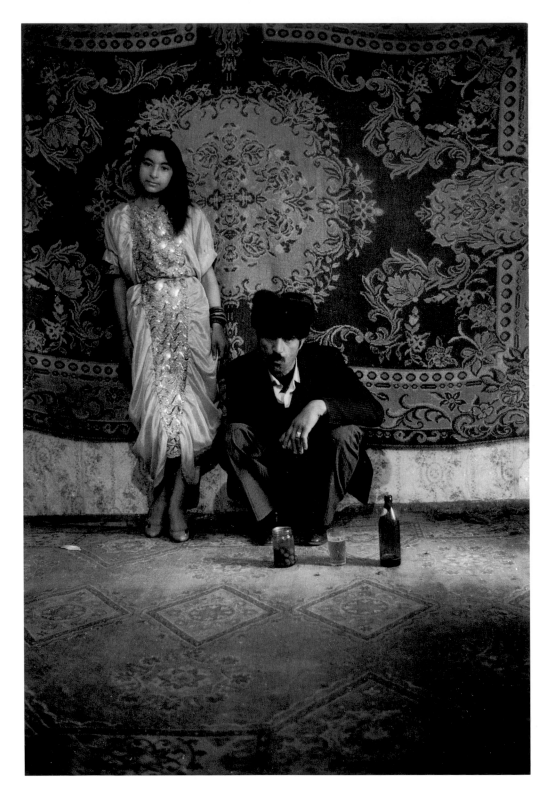

LJALJA KUZNETSOVA
GYPSIES
Odessa, 1990

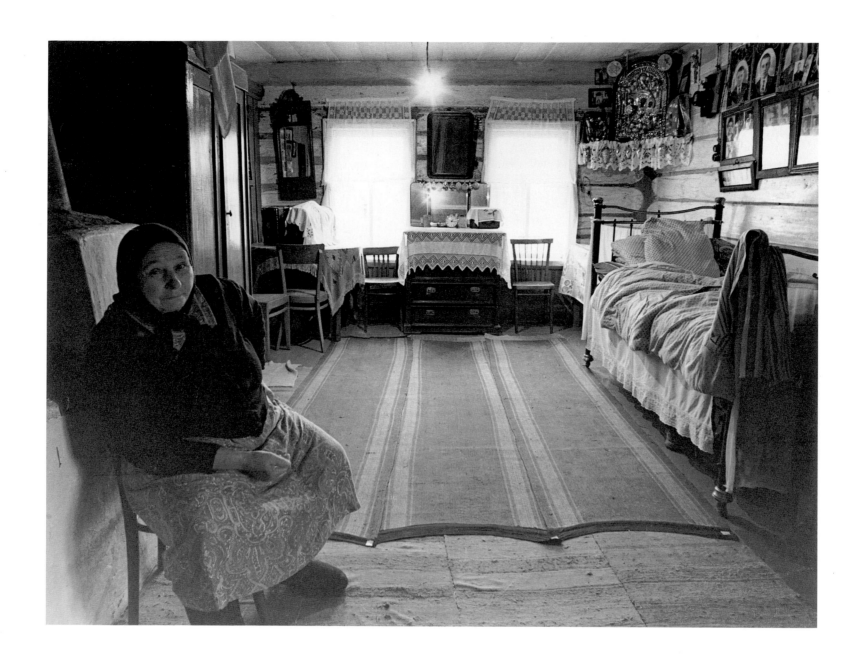

EDUARD GLADKOV
From the series, THE VILLAGE OF
TCHACHNITSY AND ALL ITS PEOPLE
Near Pereyaslavl-Zalesskiy, 1982

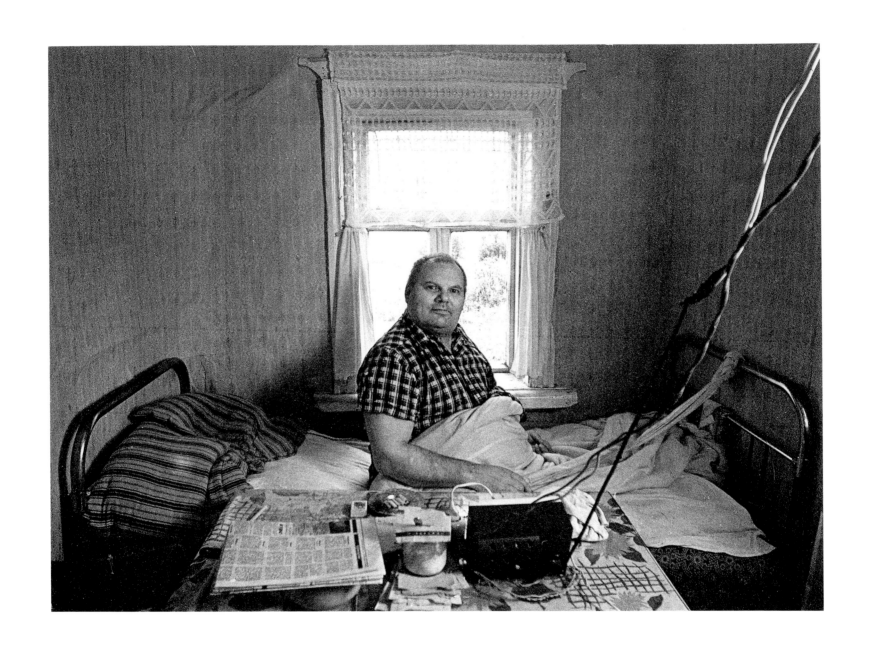

EDUARD GLADKOV
From the series, THE VILLAGE OF
TCHACHNITSY AND ALL ITS PEOPLE
Near Pereyaslavl-Zalesskiy, 1982

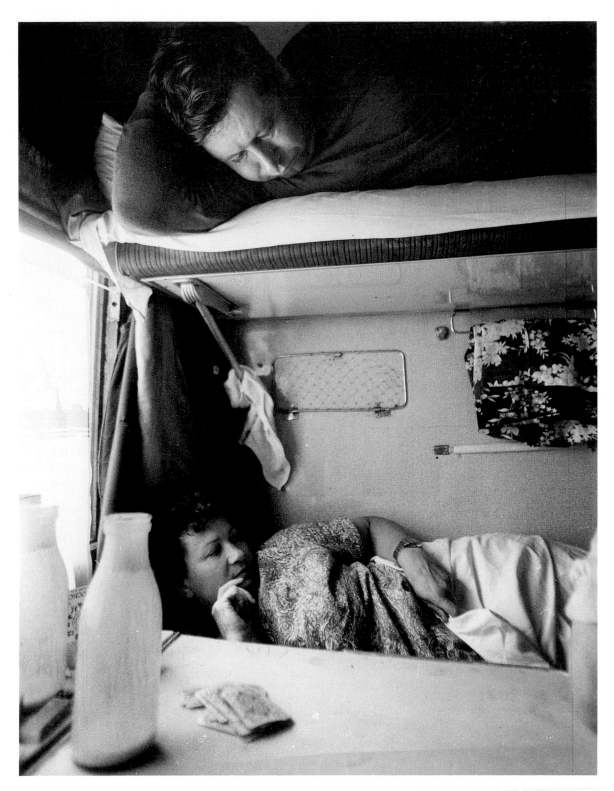

GENNADI BODROV
ON THE VORONEZH-
RIGA TRAIN
Summer 1984

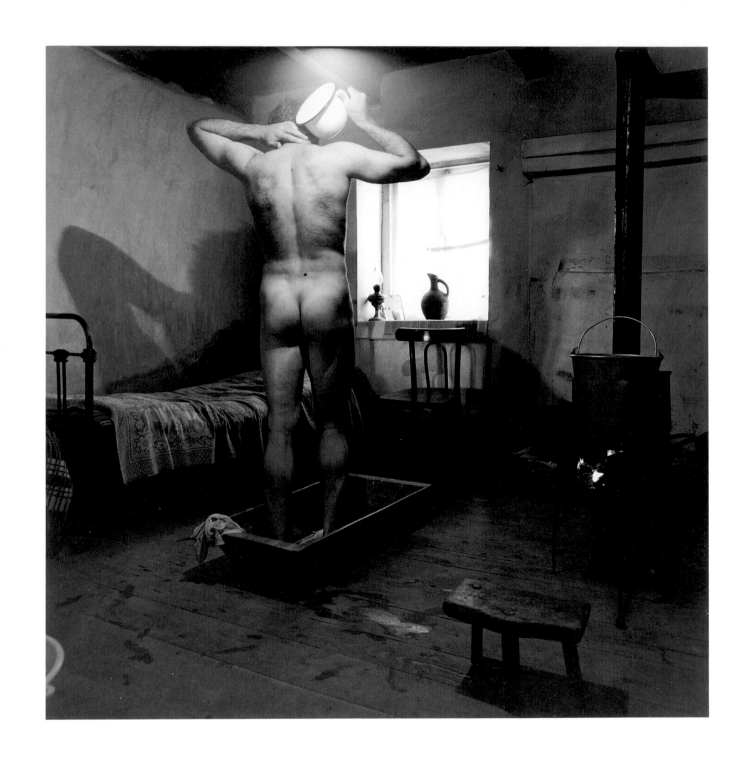

SERGEI GITMAN
Corner of a room
Village of Tsasri, Georgia, 1982

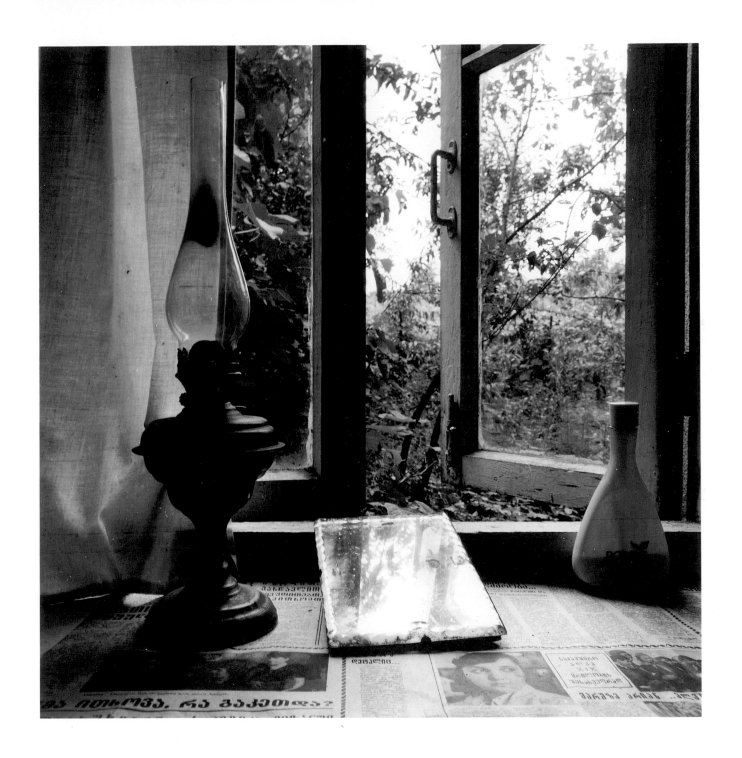

SERGEI GITMAN
Corner of a room
Village of Tsasri, Georgia, 1982

SERGEI GITMAN
Corner of a room
Village of Tsasri, Georgia, 1982

SERGEI GITMAN
Corner of a room
Village of Tsasri, Georgia, 1982

NIKOLAI SMILYK
ONCE THERE LIVED...
Kharkov Region, Ukraine, 1980

VALERI MIKHAILOV
LAST YEAR
Kazan, 1983

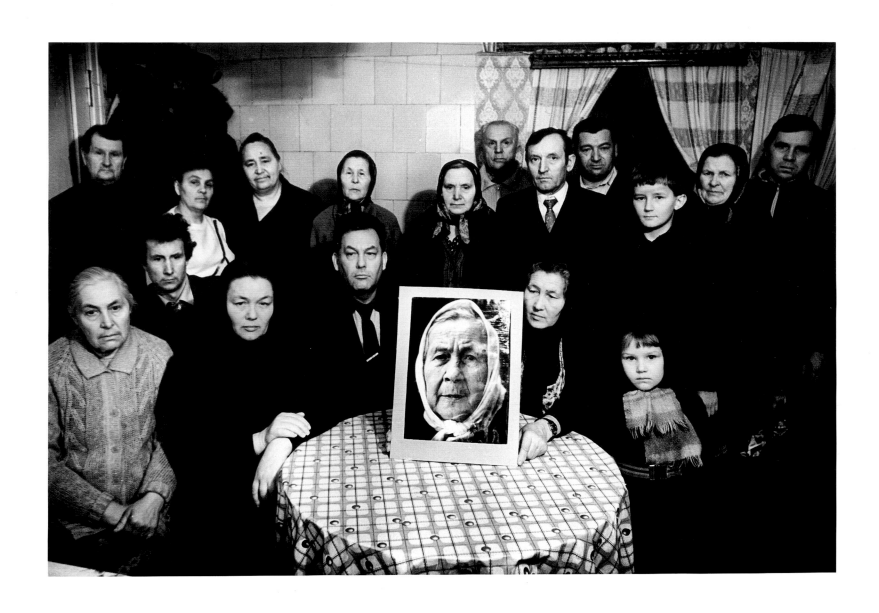

VASILI MARTINKOV
DAY OF REMEMBRANCE
Byelorussia, January 1989

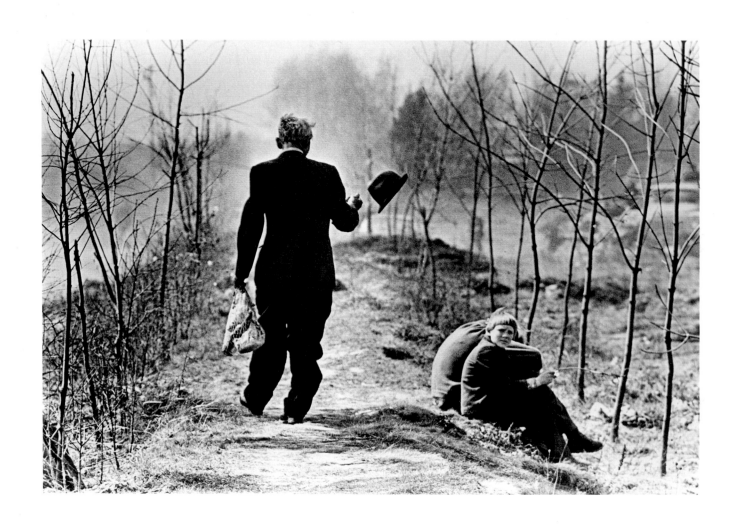

YURI RYBTCHINSKI
WIND
Near Moscow, 1981

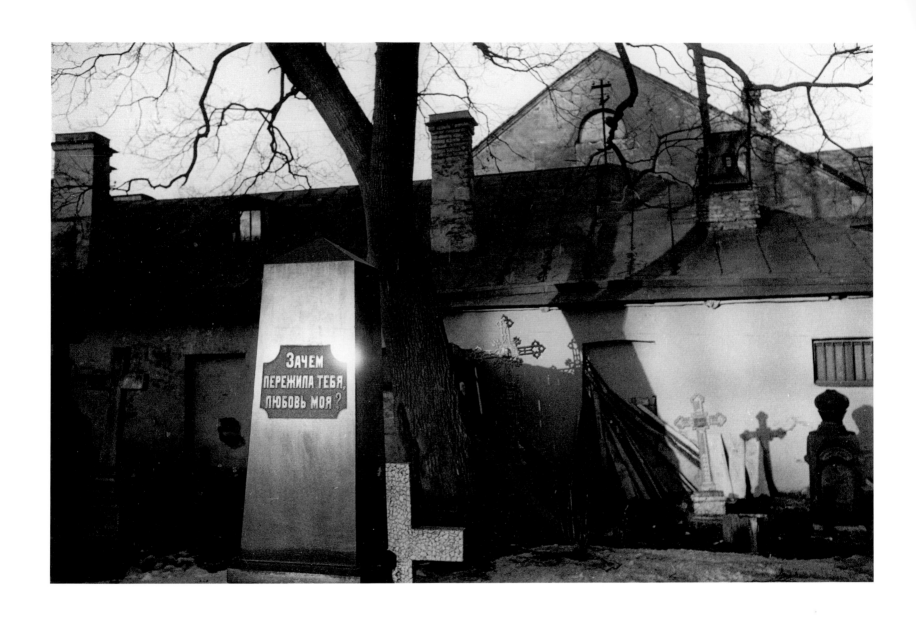

BORIS SMELOV
Smolensk Cemetery (sign on grave reads
"Why did my love outlive you?")
Leningrad, 1987

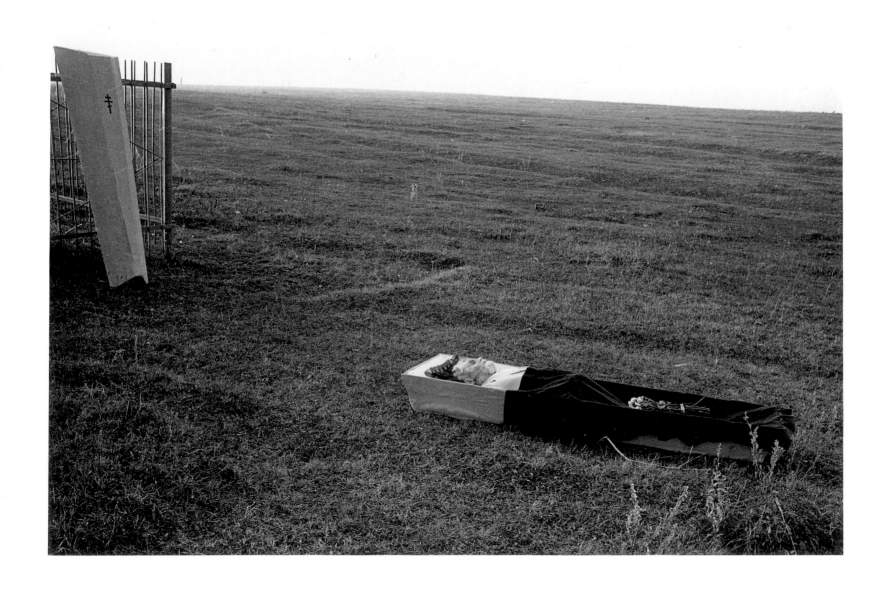

VALERI PAVLOV
Rural cemetery
Kazan, October 1988

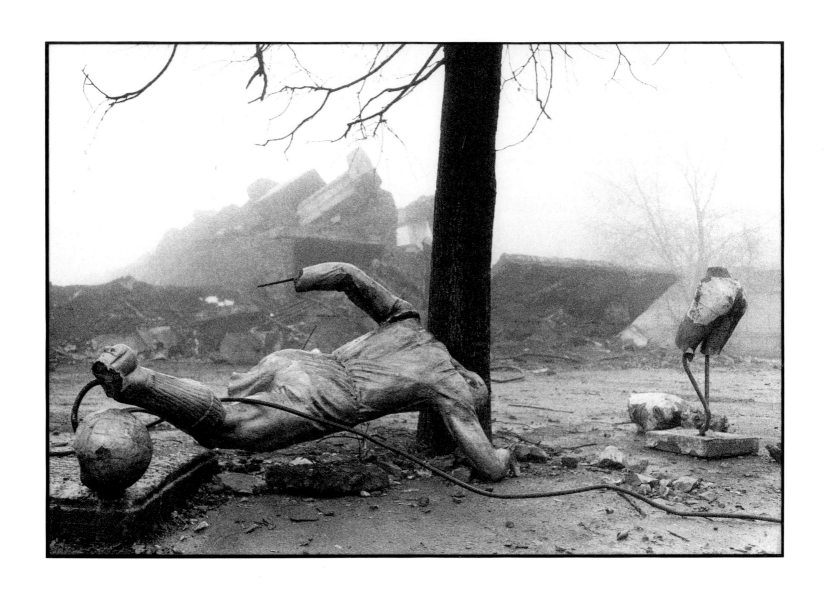

GENNADI BODROV
Untitled
Kursk, 1988

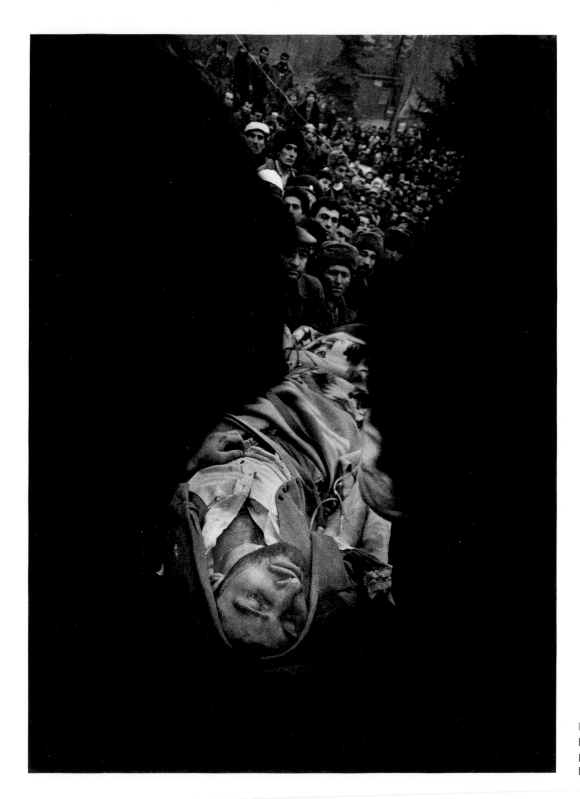

IGOR GAVRILOV
Earthquake victim
Leninakan, Armenia,
December 1988

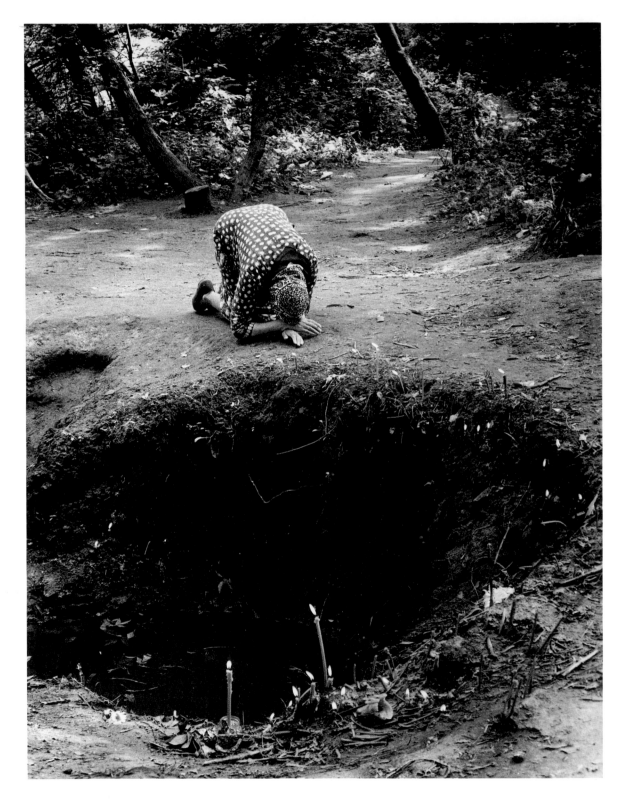

GENNADI BODROV

HOLY SPRING -OR-
SACRED SOURCE

Village of Svoboda, Kursk
Region, July 1989

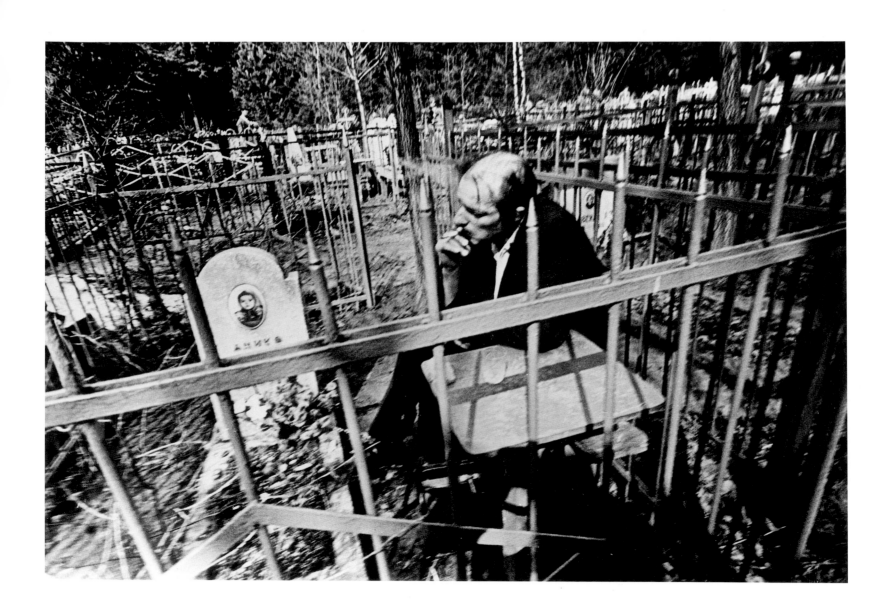

YURI RYBTCHINSKI
REMEMBRANCE
Near Moscow, 1981

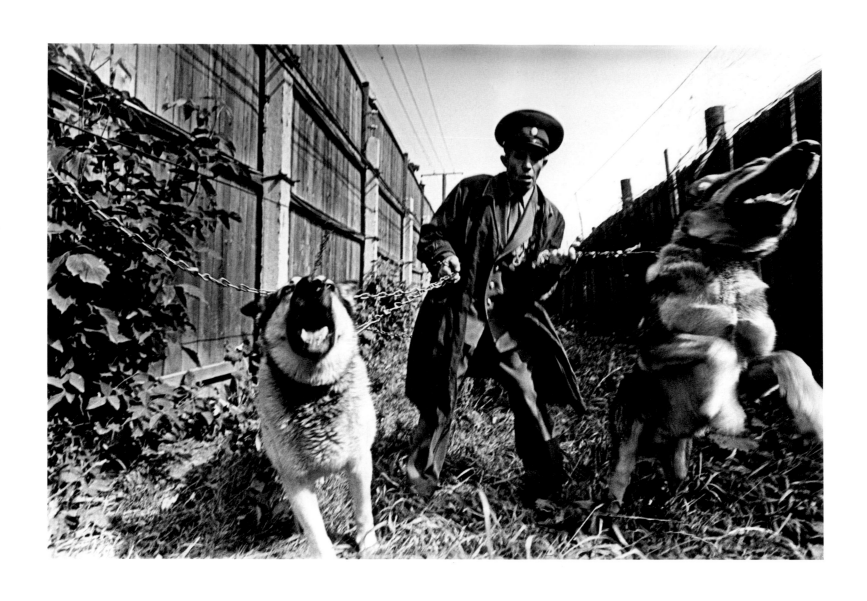

YURI RYBTCHINSKI
From the series, PRISON FOR YOUTHFUL OFFENDERS
Village of Iksha, Moscow Region, 1978

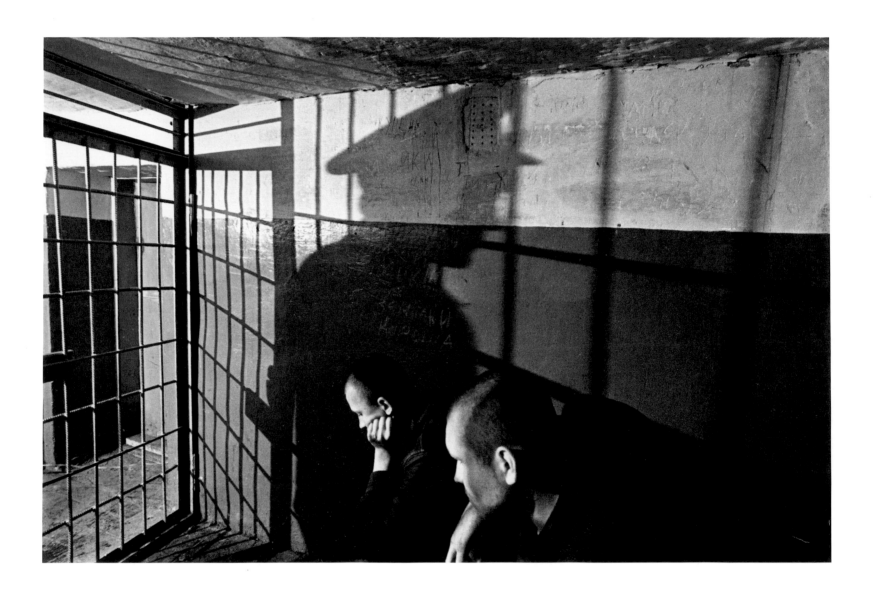

YURI RYBTCHINSKI
From the series, PRISON FOR YOUTHFUL OFFENDERS
Village of Iksha, Moscow Region, 1978

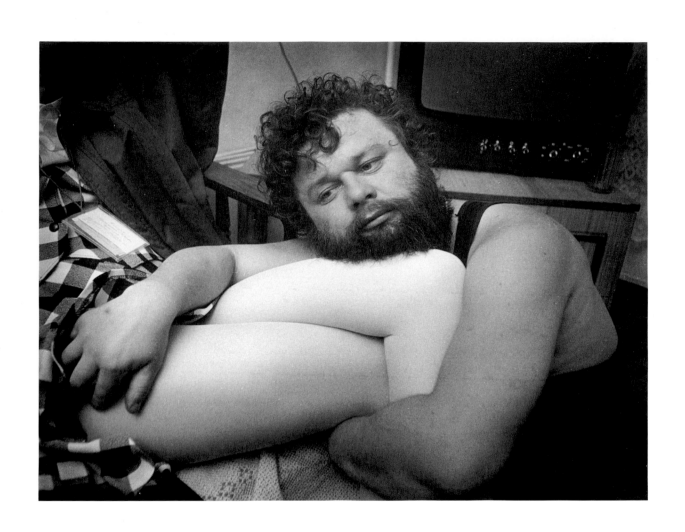

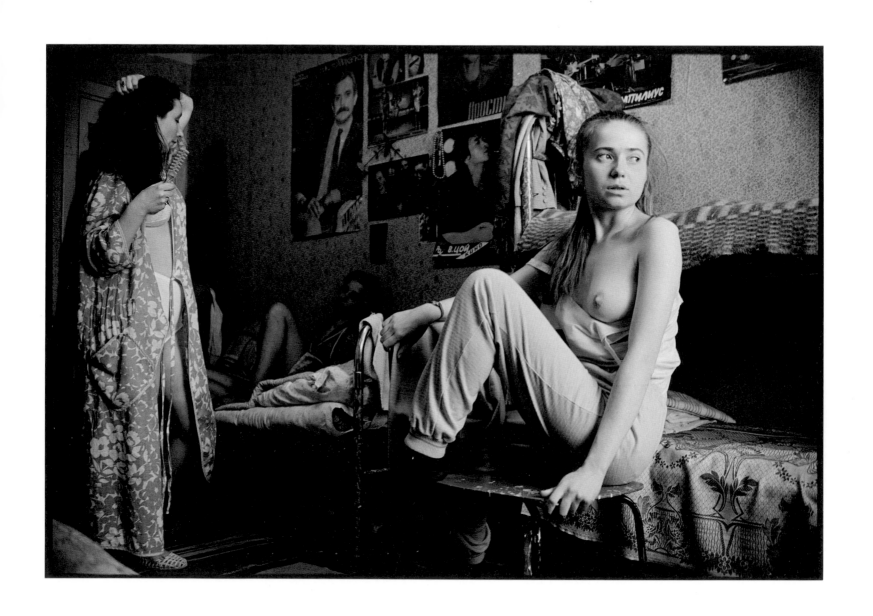

FARIT GUBAEV
Dormitory of the Kazan Theatrical Institute
Kazan, May 1990

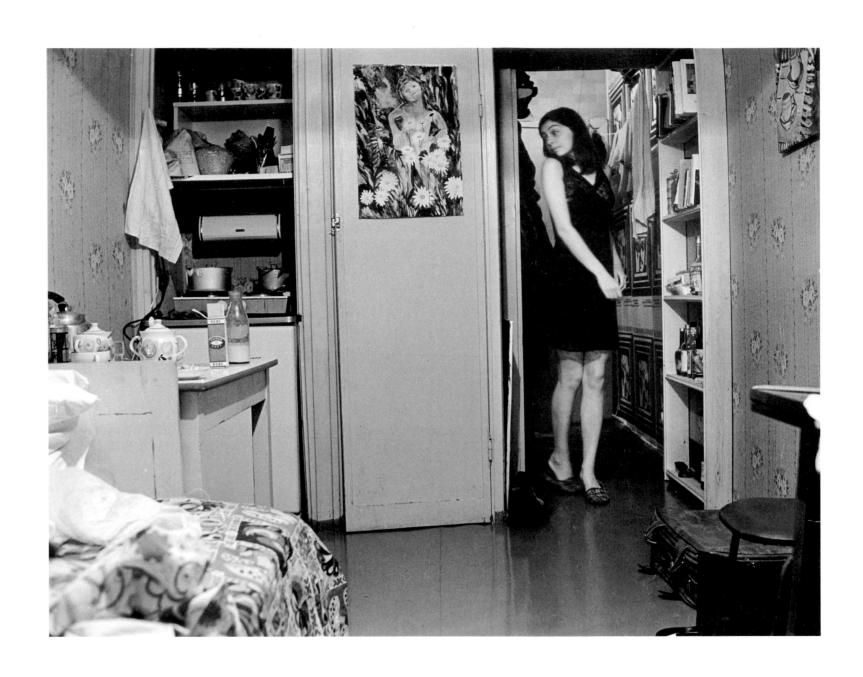

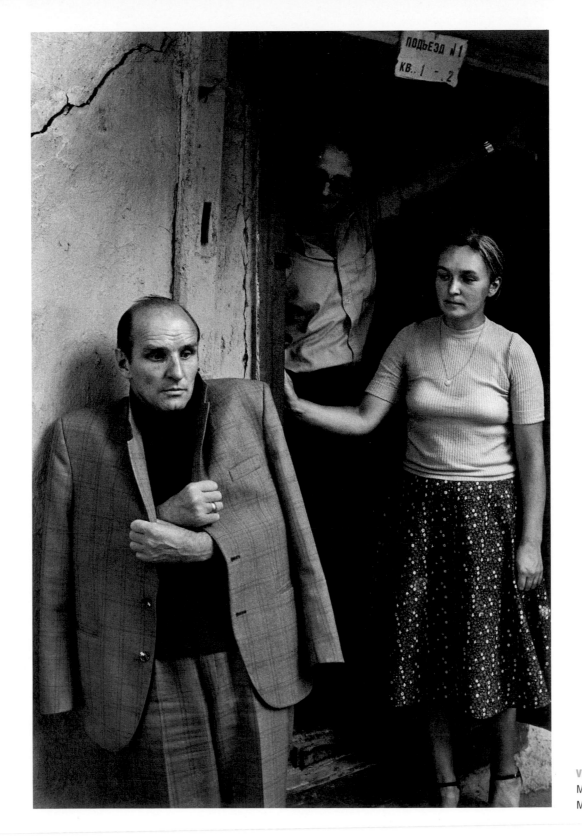

VLADIMIR SIOMIN
Movie actor Anatoli Solonitsky
Moscow, 1981

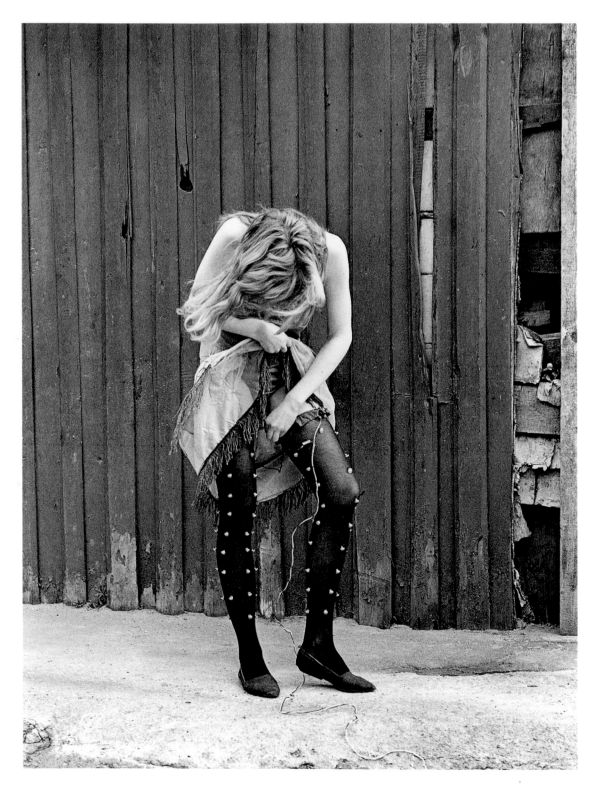

VICTOR SHUROV
Untitled
Leningrad, 1989

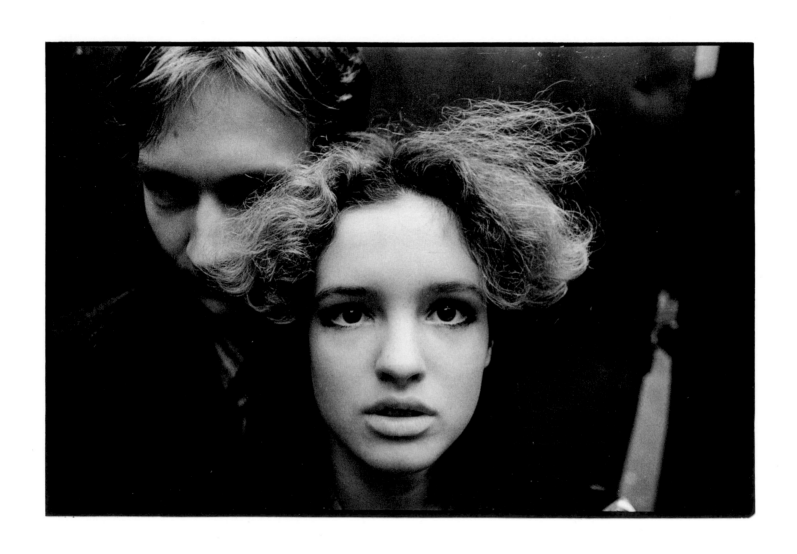

IGOR MOUKHIN
From the series, THE CITY
Moscow, 1988

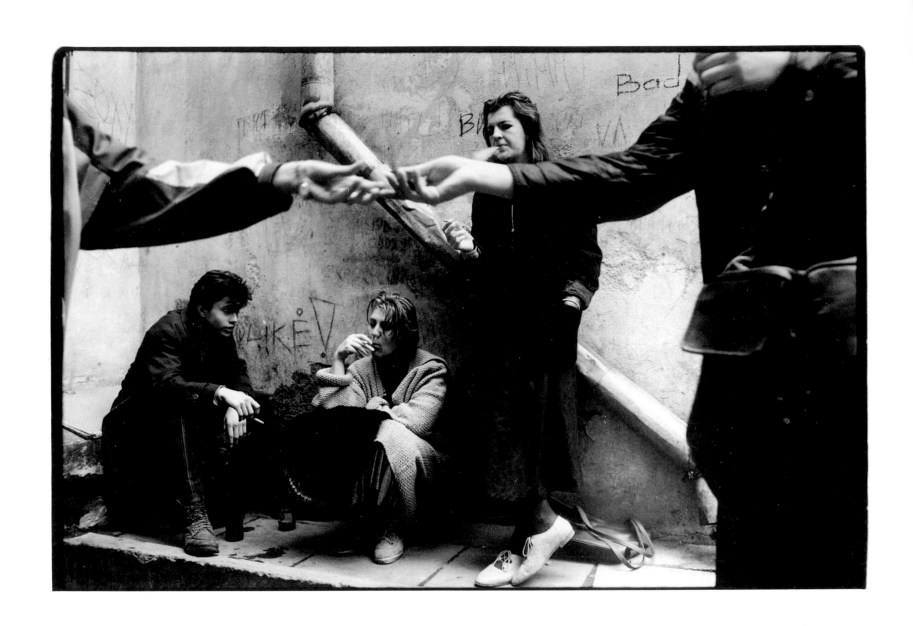

IGOR MOUKHIN
From the series, THE CITY
Vilnius, 1987

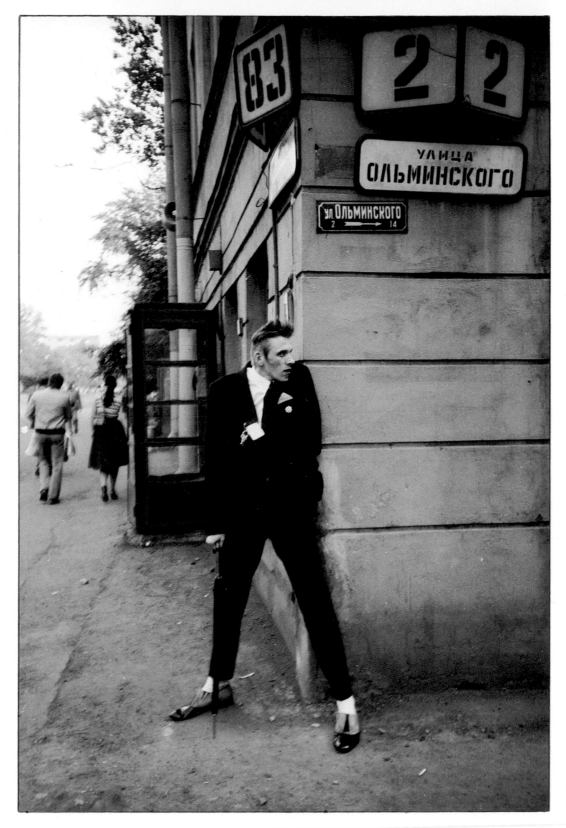

IGOR MOUKHIN
From the series, THE CITY
Leningrad, 1986

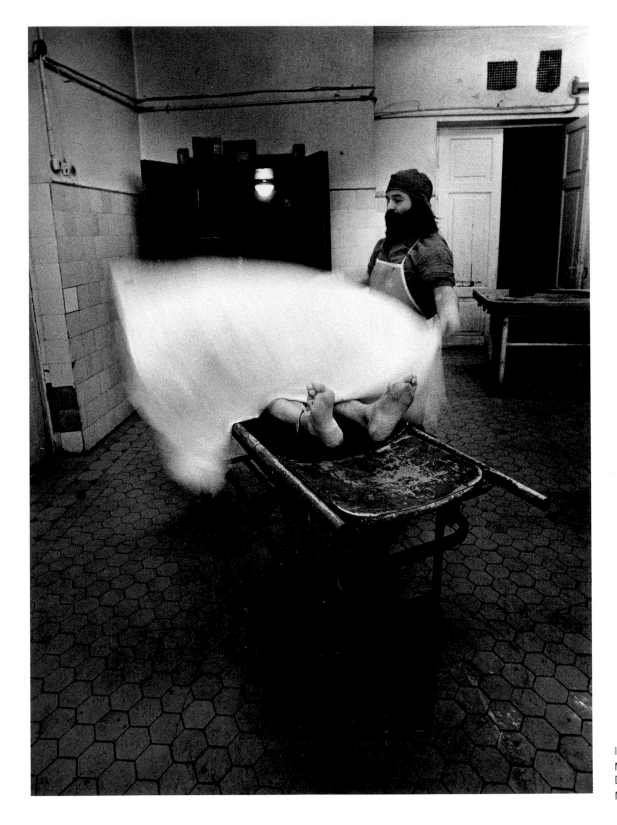

IGOR GAVRILOV
Morgue, from the series,
DRUG ADDICTION
Moscow, September 1988

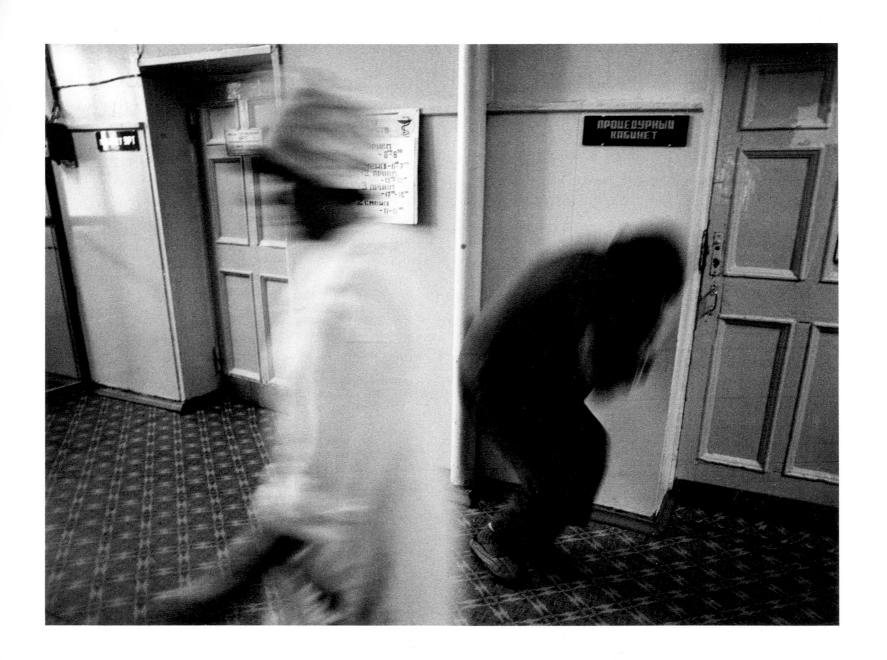

IGOR GAVRILOV
Psychiatric Hospital #15, from the series, DRUG ADDICTION
Moscow, September 1988

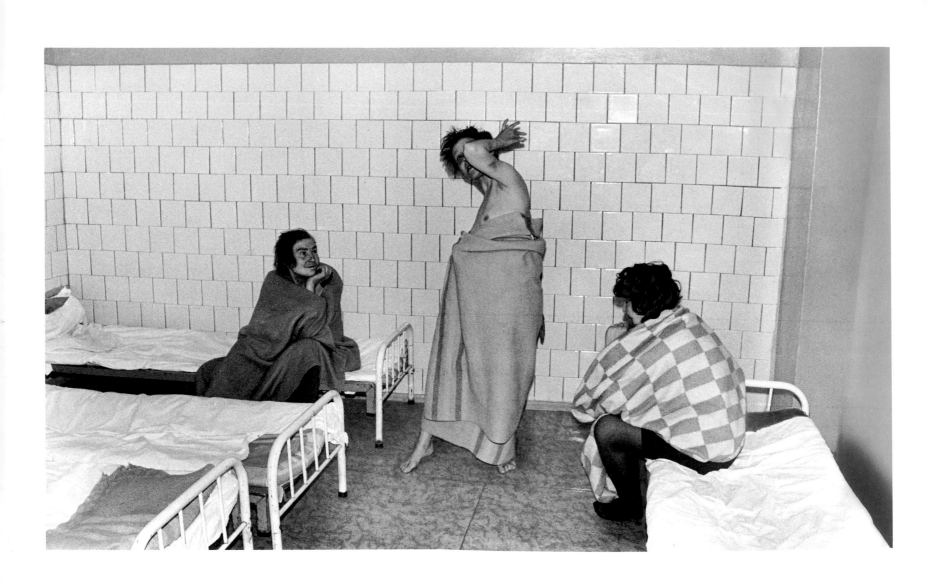

VASILI SHAPOSHNIKOV
WHEN I WAS AN ACTRESS...
Moscow Women's Detoxification Center, April 1988

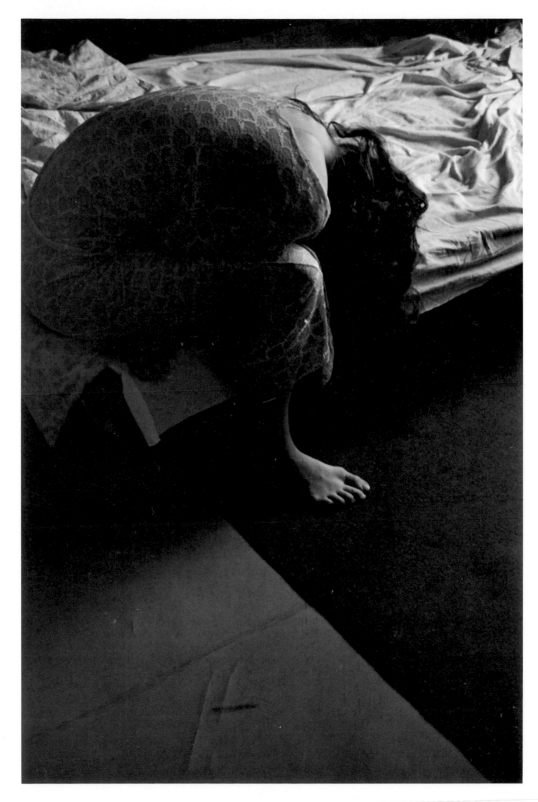

FARIT GUBAEV
TANYA
Kazan, 1989

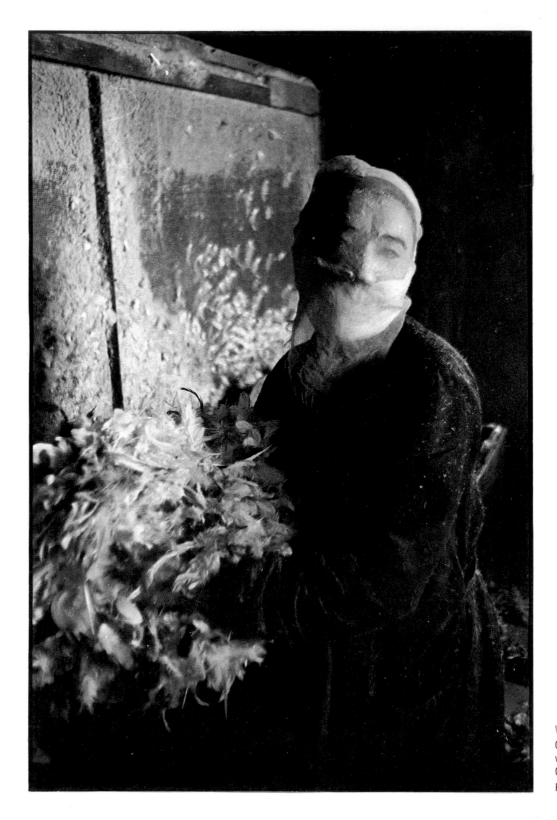

VLADIMIR ZOTOV
Gathering feathers,
workshop of Consumer
Cooperative
Kazan, 1981

YEVGENI RASKOPOV
MORNING, from the series, ON THE ROADS OF DAGESTAN
Botlikh, Dagestan, 1982

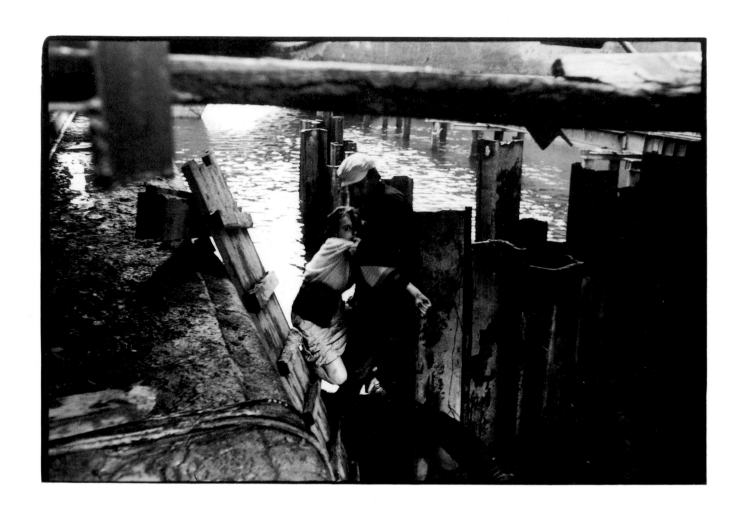

IGOR MOUKHIN
Attempted suicide
Leningrad, 1987

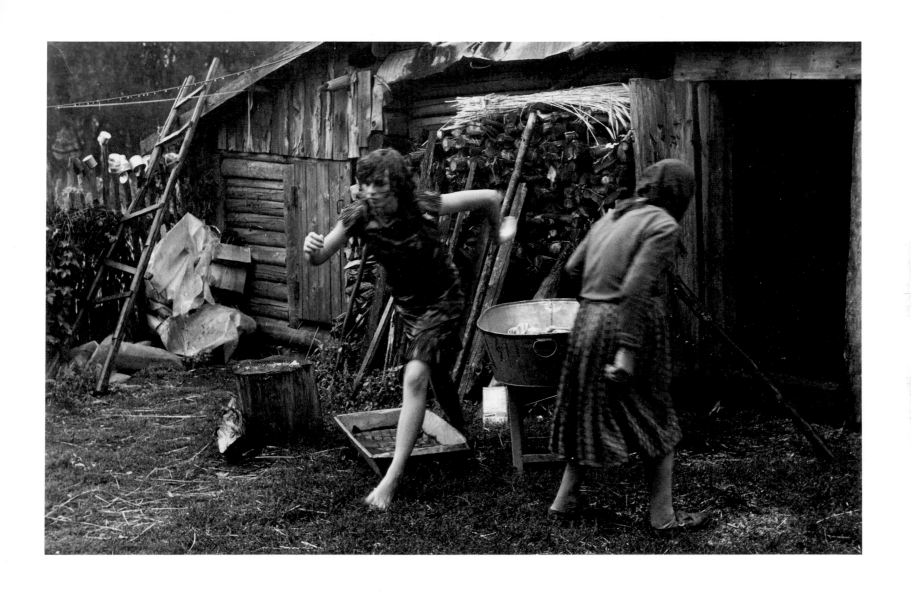

ALEXANDER STEPANENKO
DOMESTIC CONCERNS
Village of Ozerki, Karelia, 1988

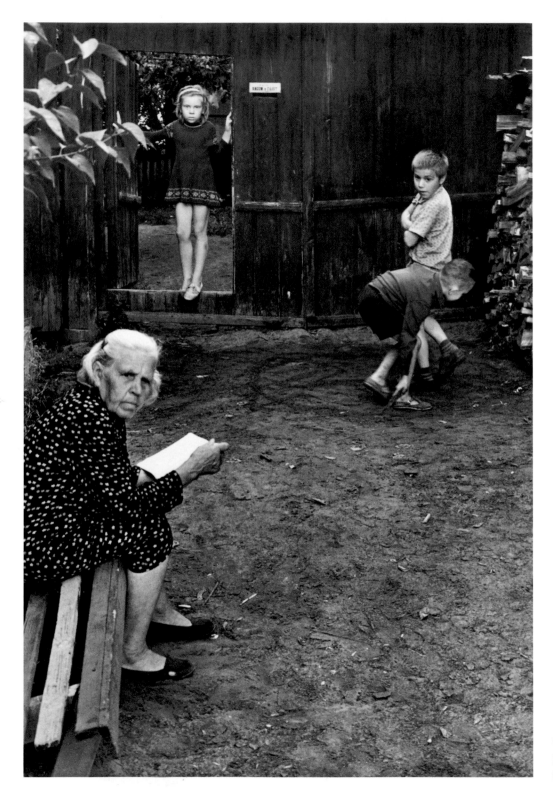

VLADIMIR SIOMIN
EVERYDAY LIFE
Solotcha, Ryazan Region, 1986

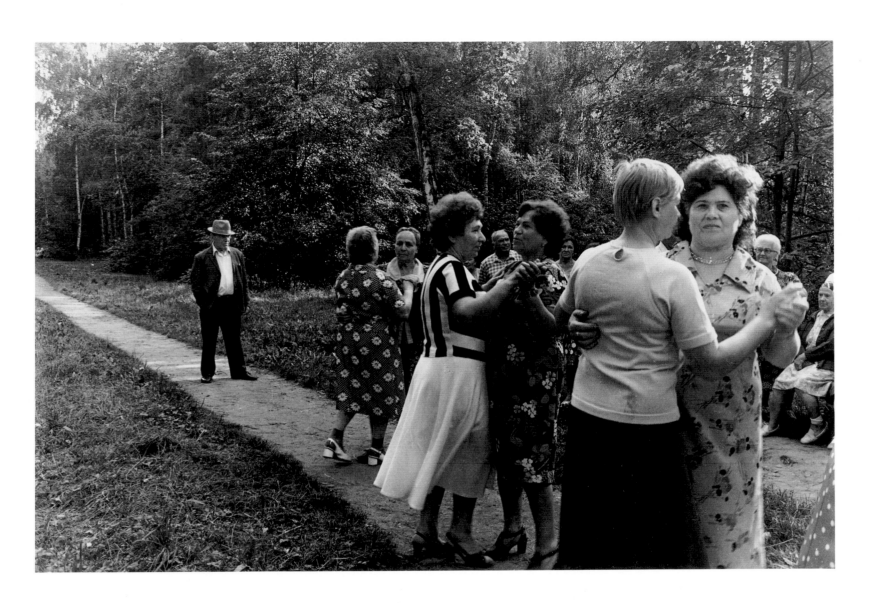

ALEXANDER GREK
Untitled
Moscow, 1983

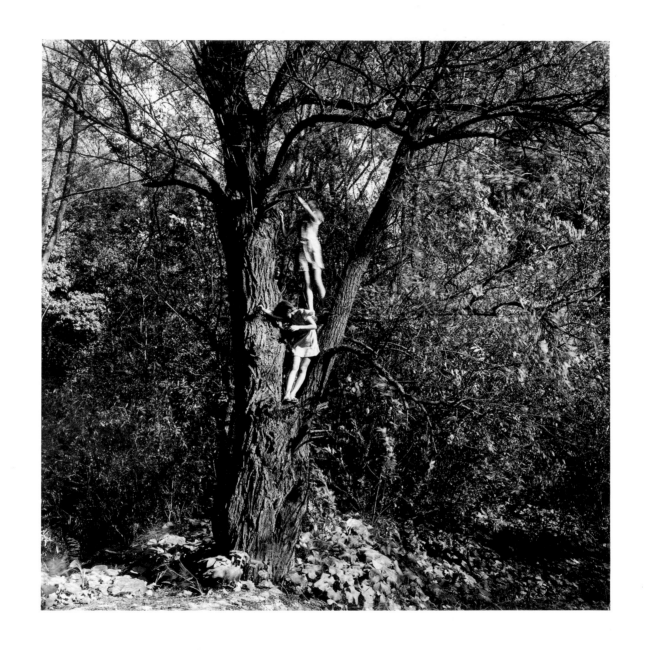

VYATCHESLAV TARNOVETSKI
Untitled
Chernovtsy, 1978

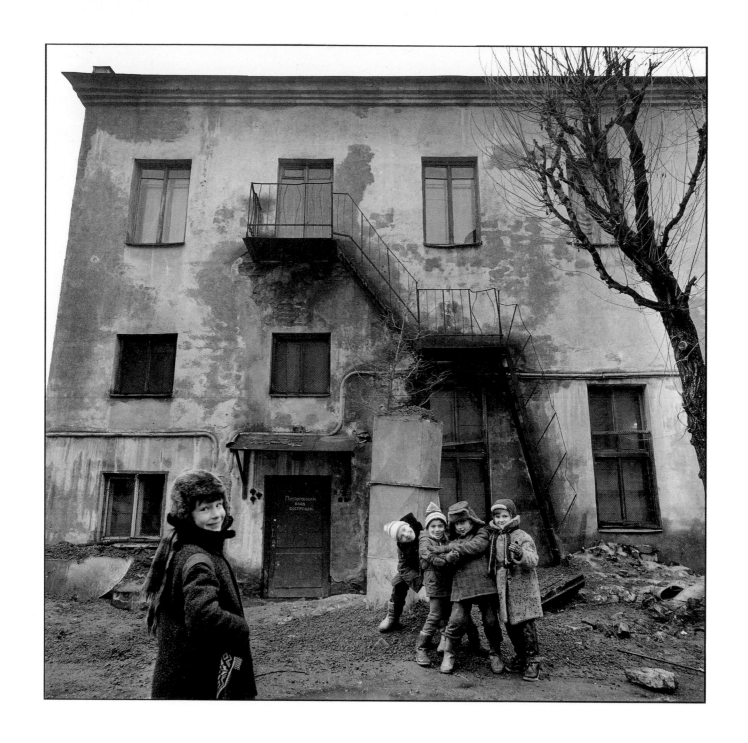

YEVGENI MOKHOREV
PETROGRAD SIDE
Leningrad, 1989

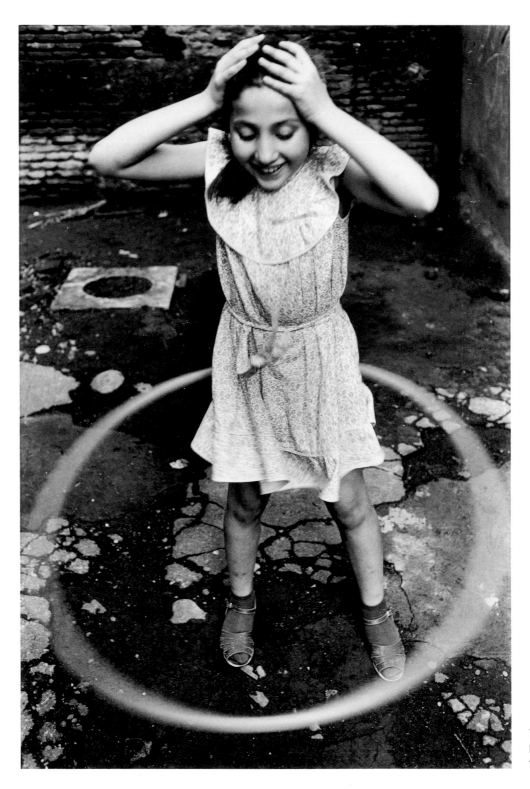

YURI MECHITOV
PLAY
Tbilisi, Georgia, 1982

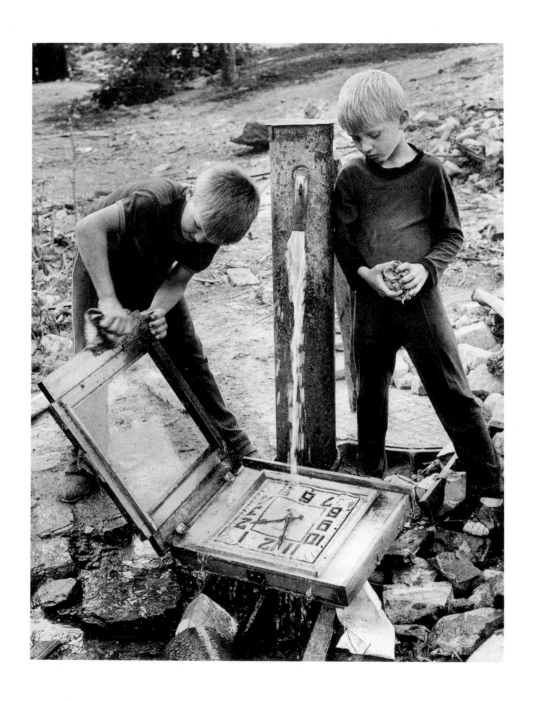

GENNADI BODROV
NEW TIME
Kursk, Spring 1989

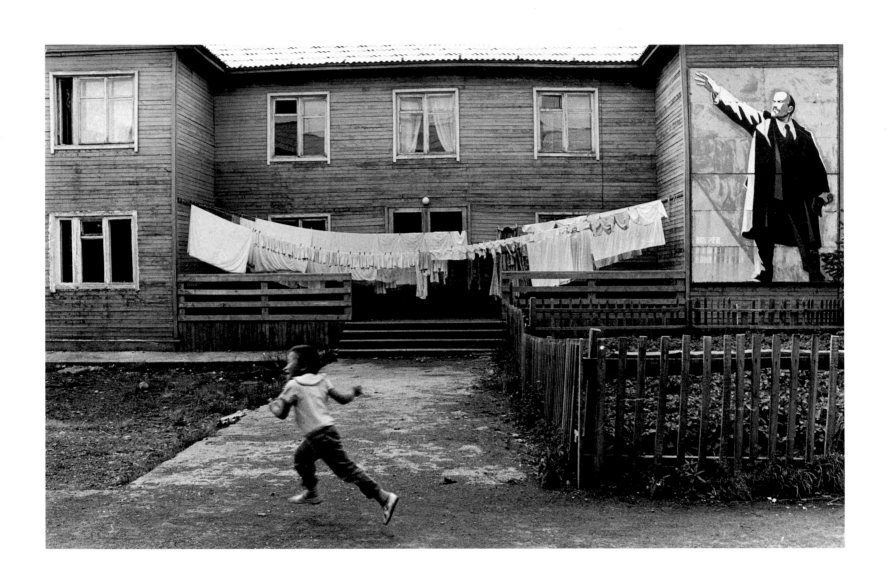

VASILI SHAPOSHNIKOV
THE BRIGHT PATH
Village of Tilichiki, Kamchatka, 1989

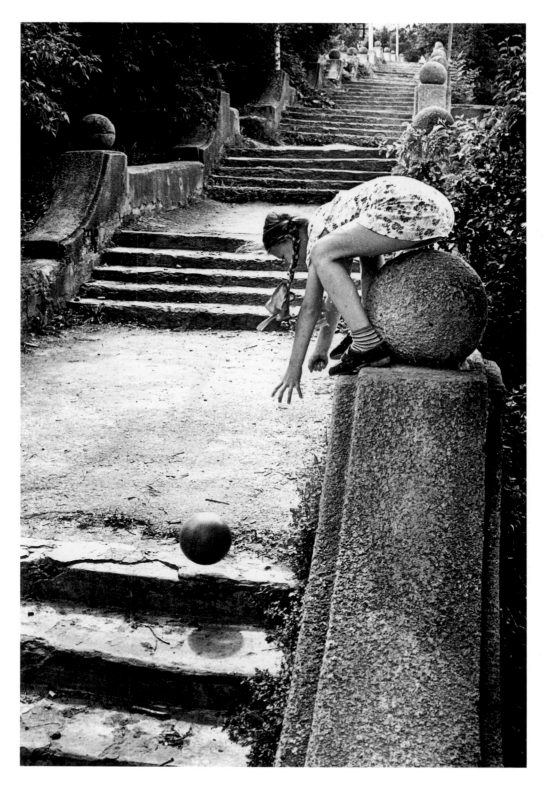

GENNADI BODROV
OLD STAIRCASE
Kursk, Summer 1978

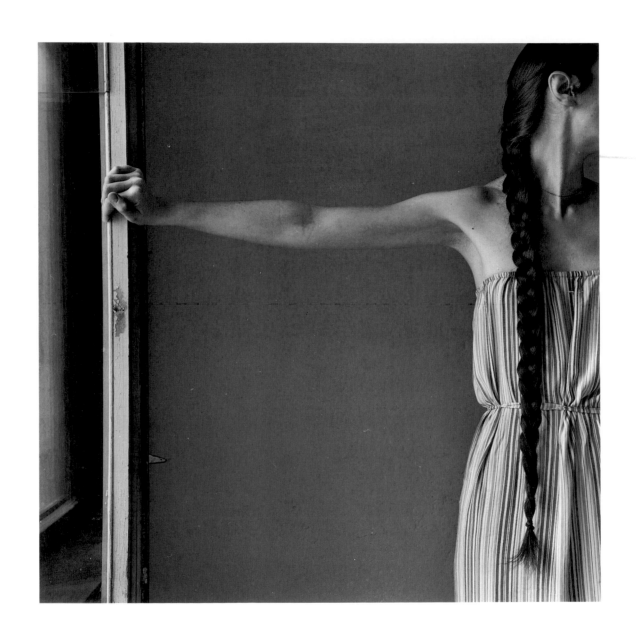

ELENA DARIKOVICH
MARGO
Moscow, 1989

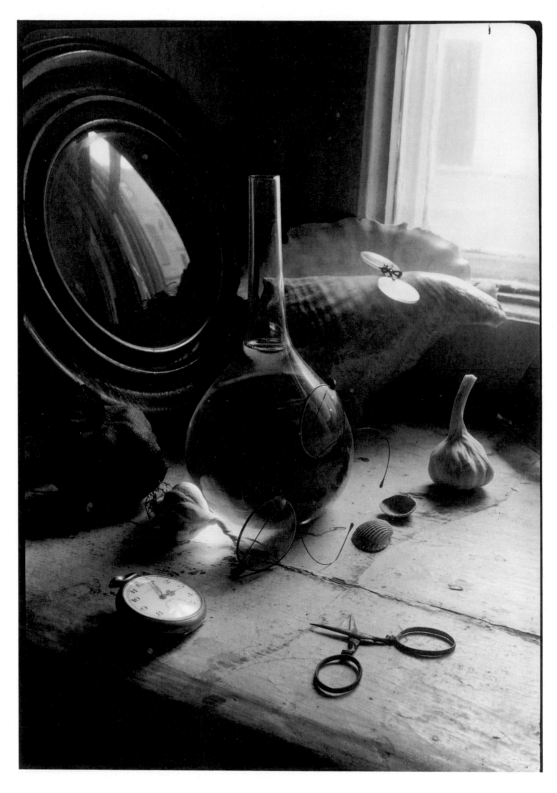

BORIS SMELOV
STILL LIFE WITH
FLASK AND CLOCK
Leningrad, 1973

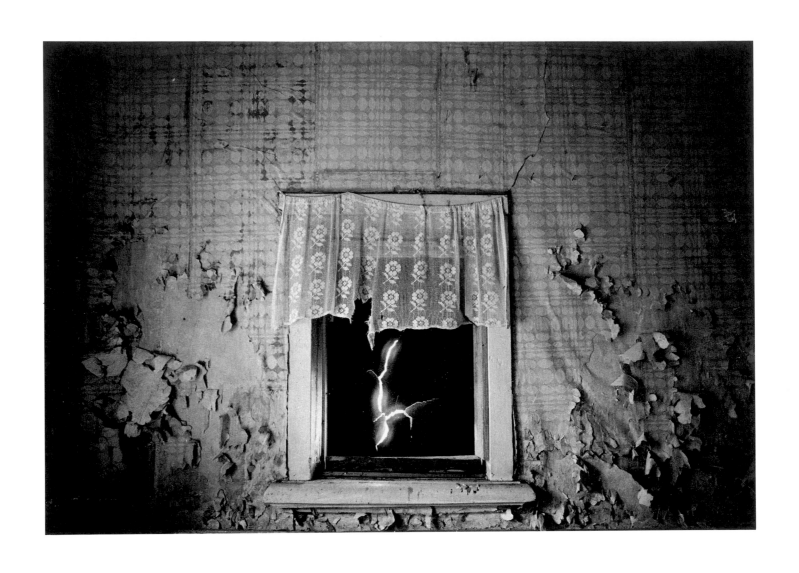

VLADIMIR FILONOV
From the series, JOURNEY INTO THE HEART OF THE COUNTRY
Village of Pogoreloye, 1989

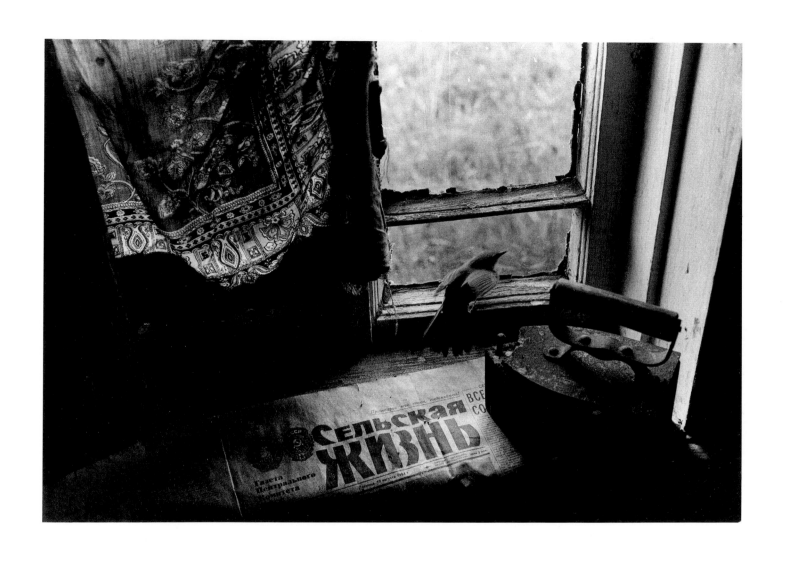

VLADIMIR FILONOV
From the series, JOURNEY INTO THE HEART OF THE COUNTRY
Village of Pogoreloye, 1989

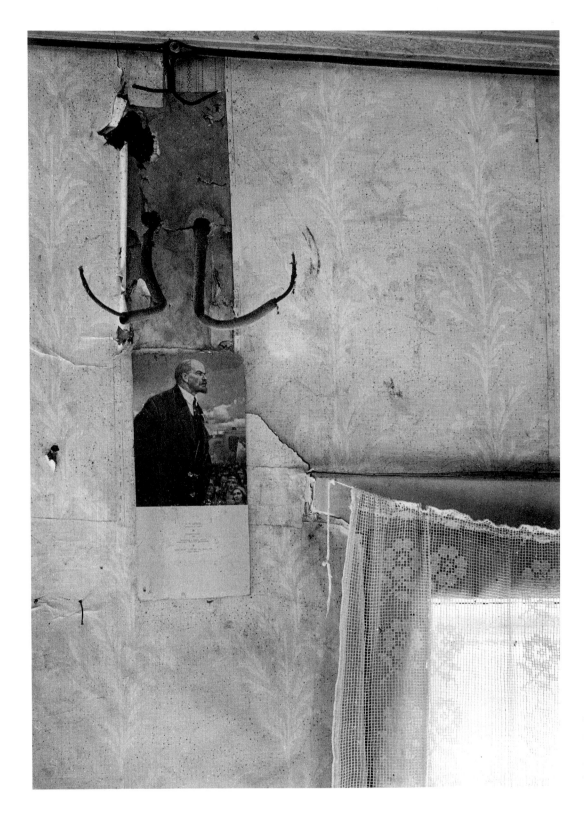

VLADIMIR FILONOV

From the series, JOURNEY INTO THE HEART OF THE COUNTRY

Village of Pogoreloye, 1989

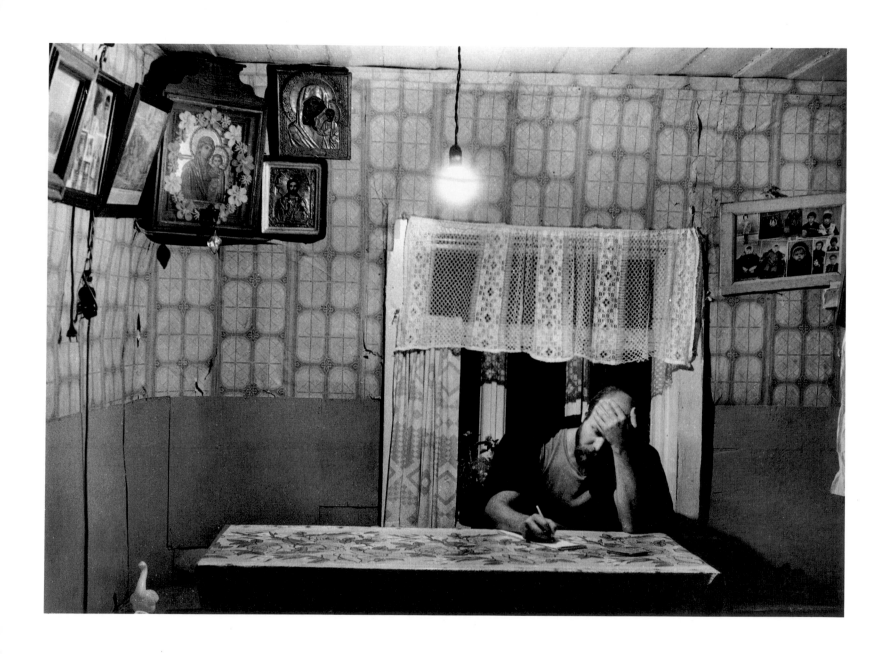

VLADIMIR FILONOV
From the series, JOURNEY INTO THE HEART OF THE COUNTRY
Village of Pogoreloye, 1989

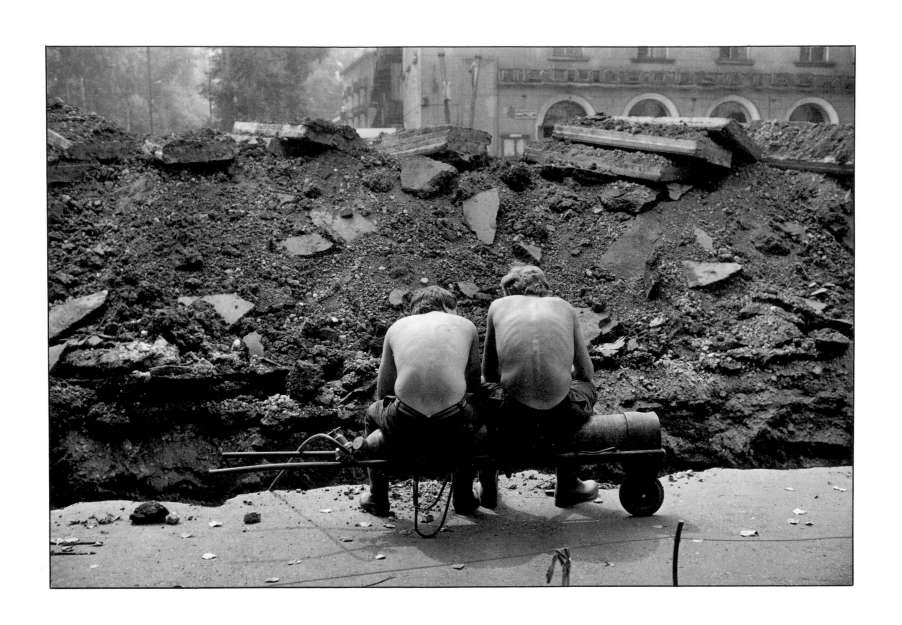

VLADIMIR SOKOLAYEV
Welders in metallurgical plant
Novokuznetsk, 1983

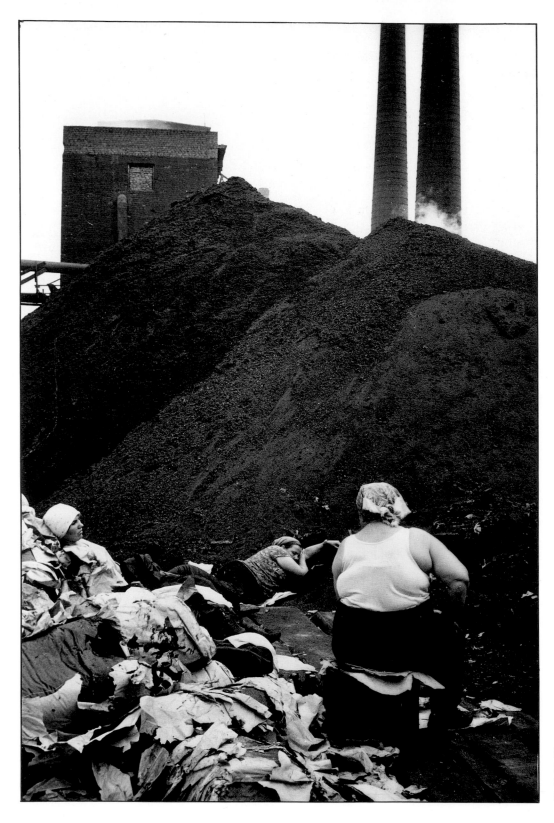

VLADIMIR SOKOLAYEV
Lunch break at the
metallurgical plant
Novokuznetsk, June 1978

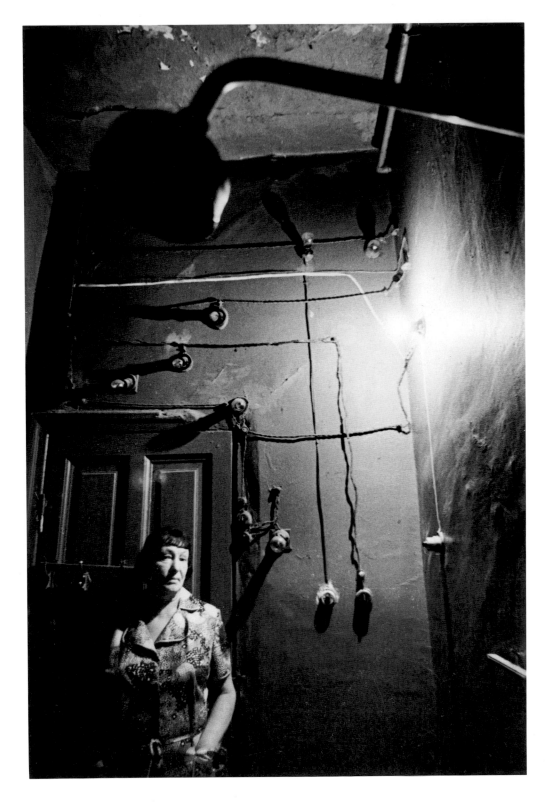

YURI ROST
MOTHER IN THE
BATHROOM OF A
COMMUNAL
APARTMENT
Kiev, 1980

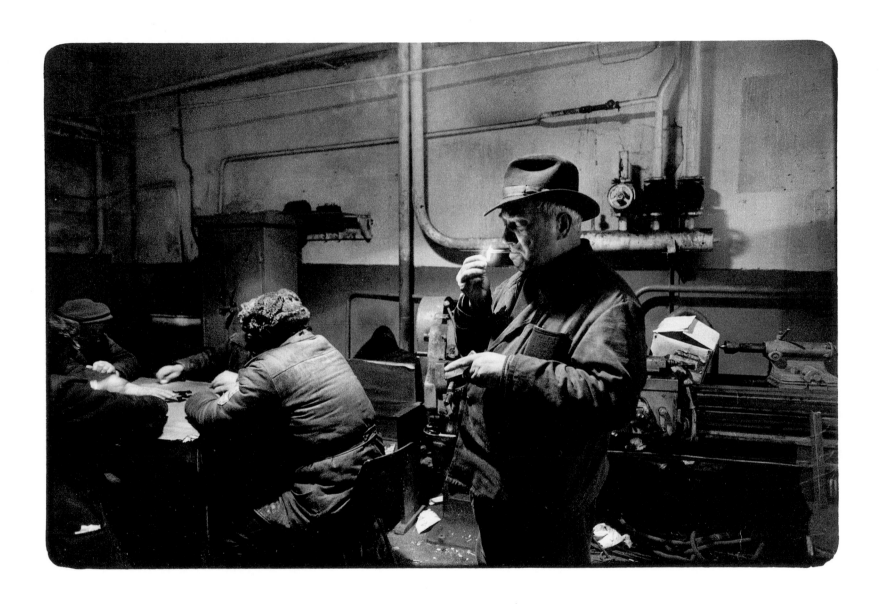

VLADIMIR FILONOV
DAY IN THE LIFE
Ventilation Equipment Plant, Zaporozhye, 1987

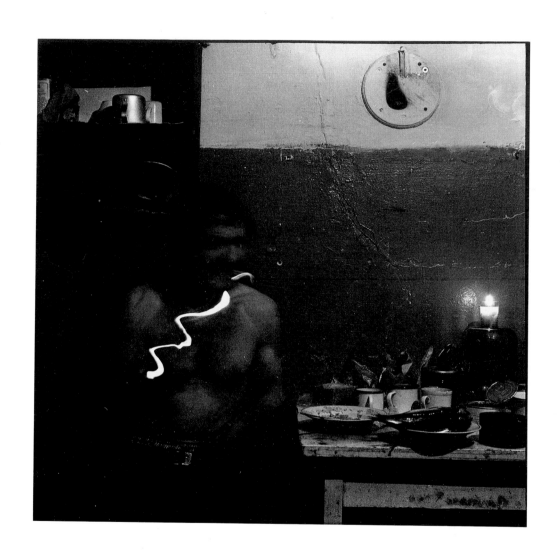

NIKOLAI KULEBIAKIN
Untitled
Sovlets Islands, 1988

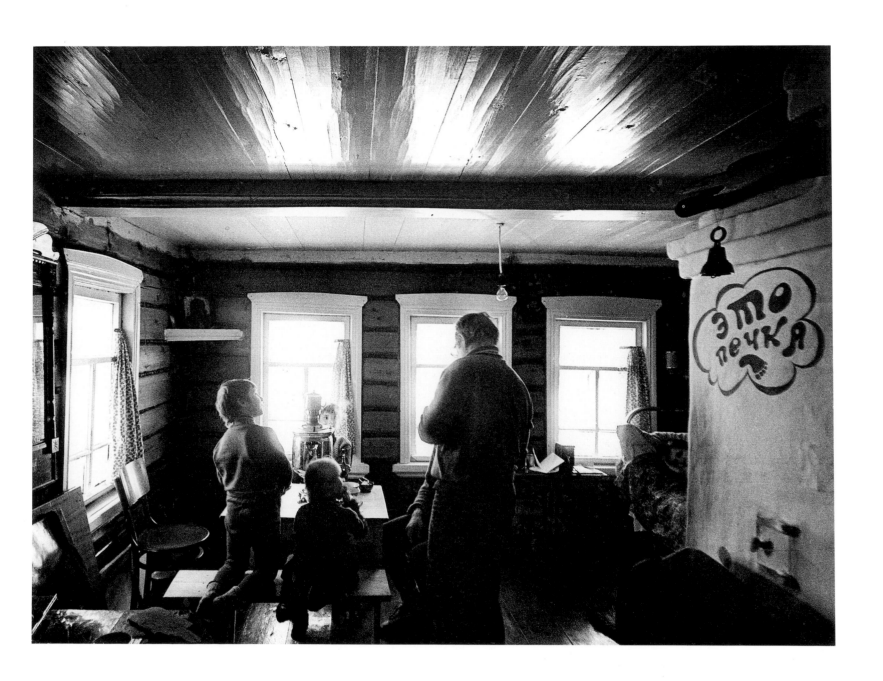

VICTOR SHUROV
DACHA DWELLERS (sign reads "This is a stove")
Village of Kurochnino, Volga River, 1985

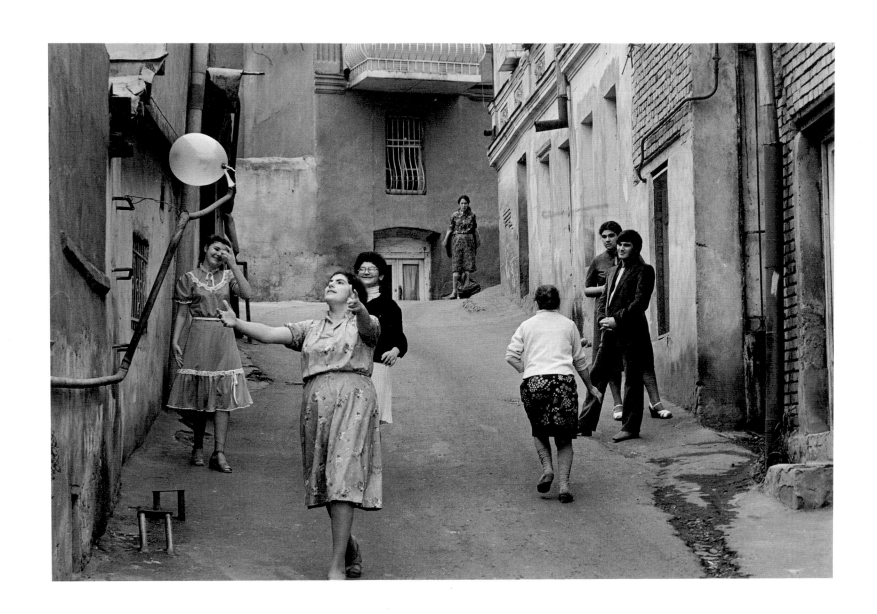

RIFKHAT YAKUPOV
SUNDAY IN TBILISI
Georgia, 1984

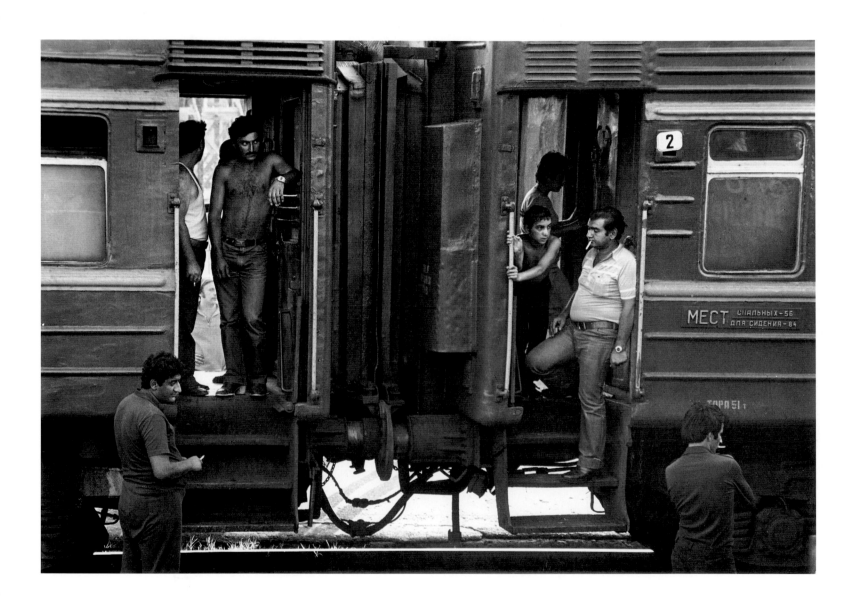

MICHAIL NASBERG
ORIENTAL EXPRESS
Sukhumi, 1986

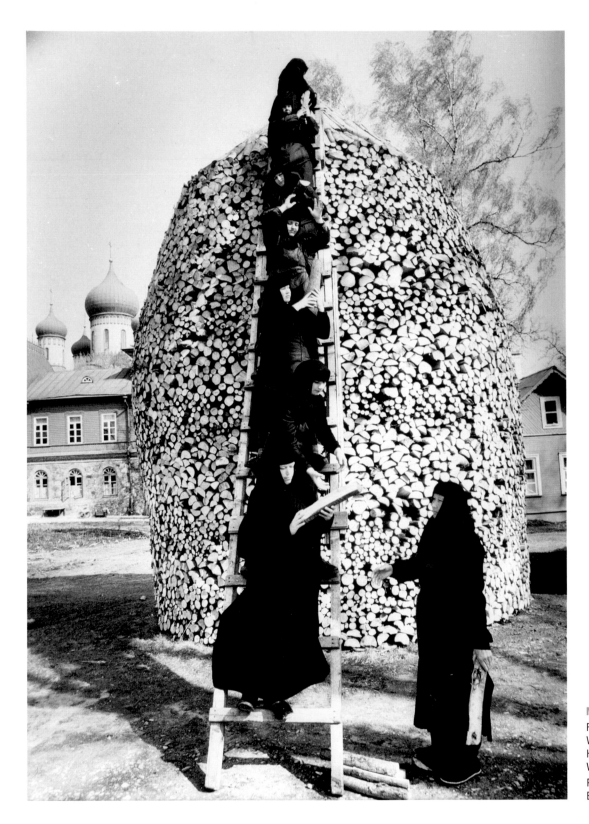

MARINA YURCHENKO
From the series,
WORKDAYS AND
HOLIDAYS OF A
WOMEN'S CLOISTER
Pyukhtitsy Convent,
Estonia, May 1987

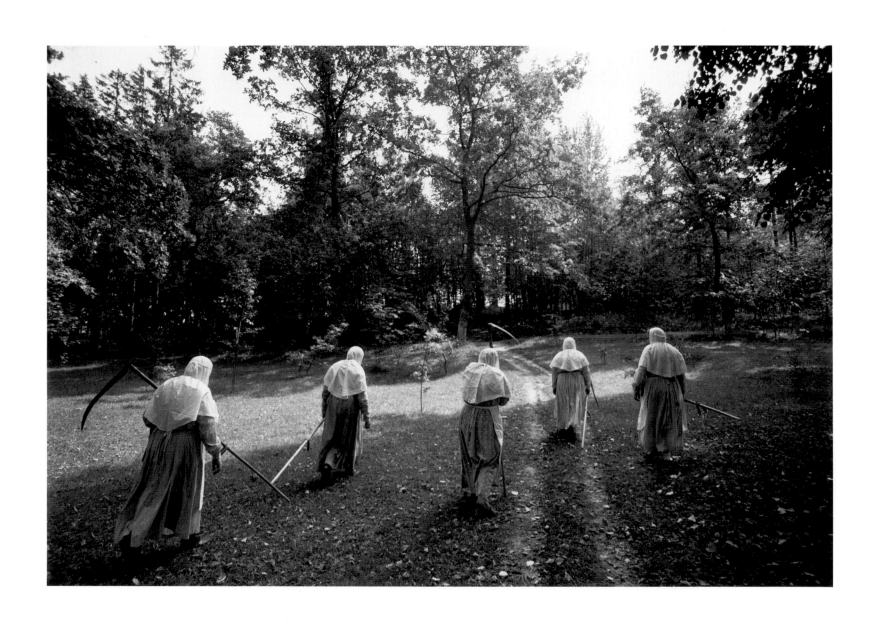

MARINA YURCHENKO
From the series, WORKDAYS AND HOLIDAYS OF A WOMEN'S CLOISTER
Pyukhtitsy Convent, Estonia, June 1984

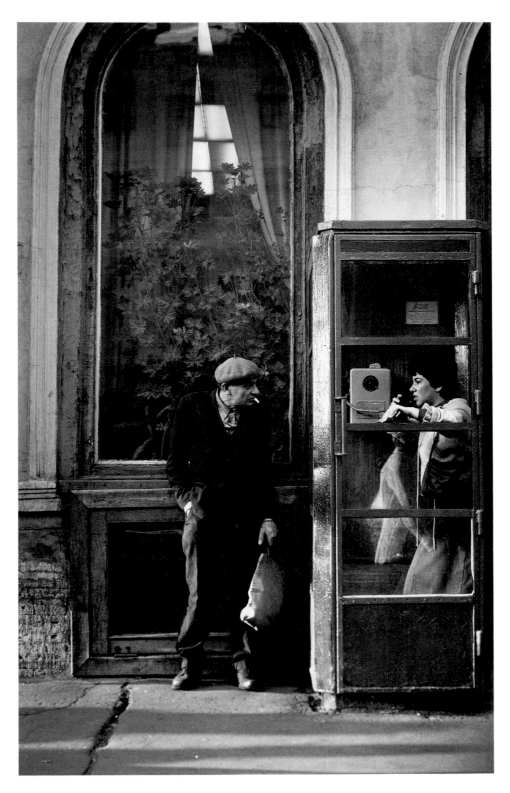

YURI ZHURAVSKI
Nevsky Prospekt
Leningrad, Summer 1982

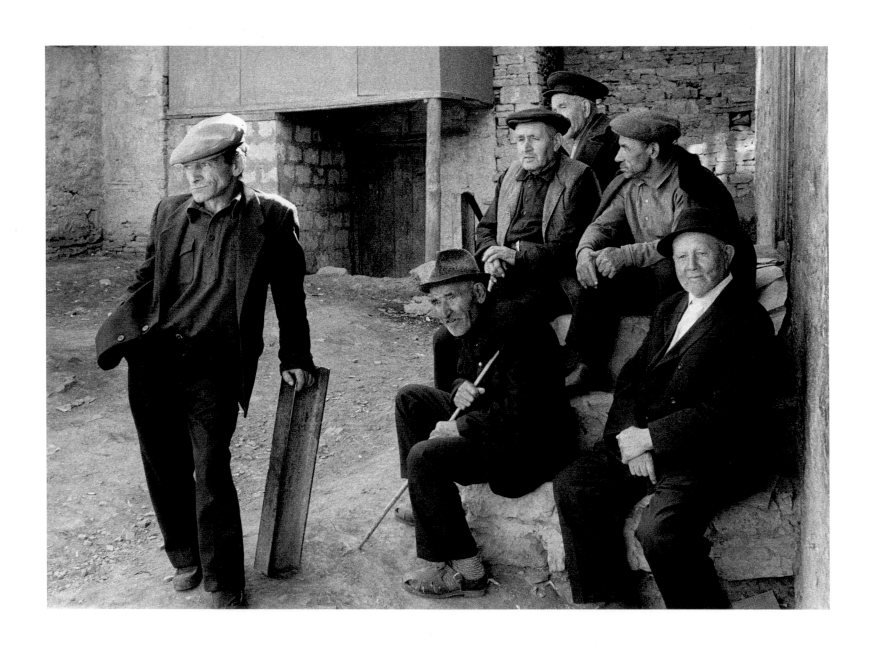

VLADIMIR SIOMIN
Craftsmen
Village of Kubachi, Caucasus, 1989

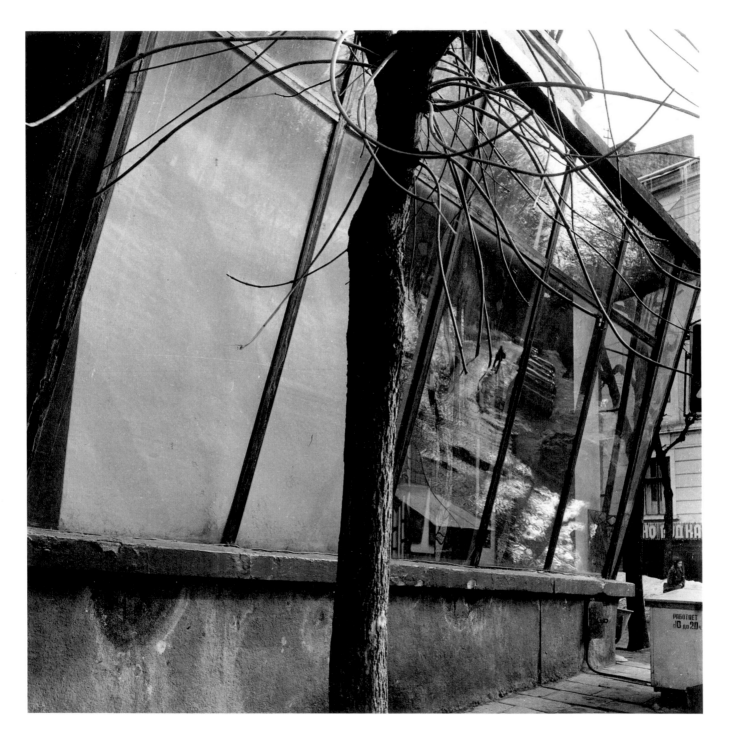

VYATCHESLAV TARNOVETSKI
Untitled
Chernovtsy, 1985

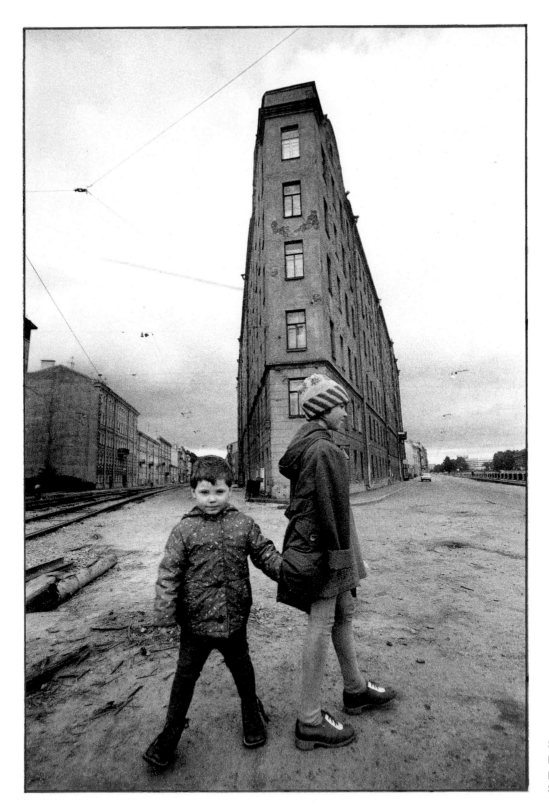

SERGEI KOROLJOV
FONTANKA 199
Fontanka River, Leningrad,
September 1986

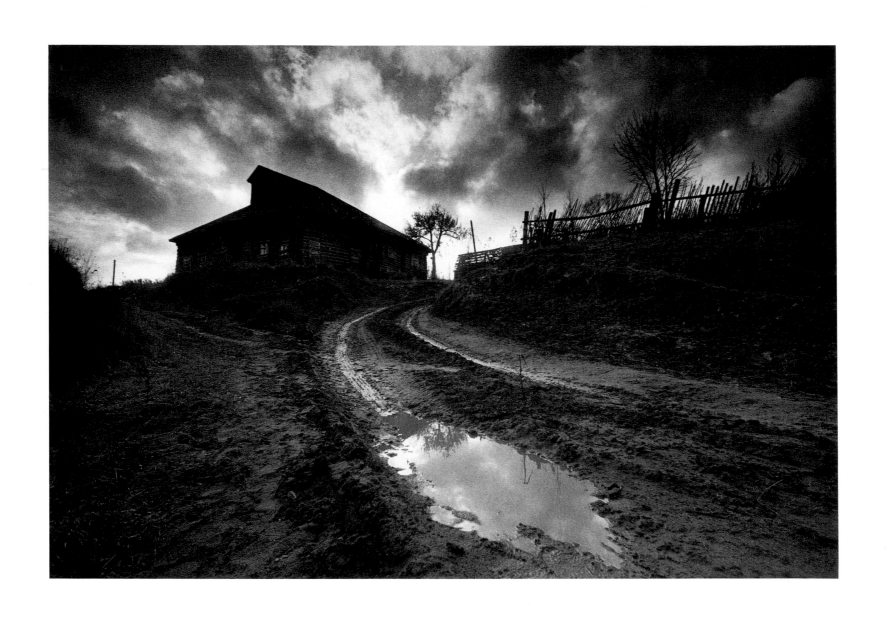

VLADIMIR FILONOV
From the series, JOURNEY INTO THE HEART OF THE COUNTRY
Village of Pogoreloye, 1989

BIOGRAPHIES

GENNADI BODROV works with organized studio material as well as sponta-neous subjects drawn from his surroundings. In his social and journalistic images, Bodrov strives for "alienation and uninvolvement in what's going on." Henri Cartier-Bresson is "probably the greatest influence" on his work. Bodrov was born in 1957 in Solntsy in the Novgorod Region. He now lives in Kursk. (Photographs pages 41, 53, 67, 78, 80, 84, 105, 107)

VLADIMIR BOGDANOV was born in 1942 in Blagoveshchensk in the far eastern Amur Region. Bogdanov names the Magnum photographers as the greatest influence on his work and says, "My primary interest lies in photo documents." (Photograph page 86)

ELENA DARIKOVICH began photographing in 1976 and met photographer Boris Savelev shortly thereafter. Savelev profoundly influenced her ap-proach to photography, which combines abstraction with realism. "I make pure photography, without symbols," says Darikovich. "I am interested in man, the environment, light, and line." Darikovich, born in 1951, is a native of Moscow. (Photographs pages 38, 108)

VLADIMIR FILONOV says, "I am engrossed in social themes. I am a re-searcher who protests the Central Committee of the Communist Party of the Soviet Union, and especially its ruling politburo." Filonov was born in 1948 in Tbilisi, Georgia. By profession he is an engineer. He has lived in Baku (Azerbaijan), the Volga Region, and Zaporozh'ye in the Ukraine. (Photo-graphs pages 28, 49, 110, 111, 112, 113, 117, 128)

IGOR GAVRILOV was born in 1952 in Moscow where he still resides. The most important inspiration for his work is "the events now taking place in our country. I want to reflect on the times in which I live as honestly and completely as possible." Gavrilov works as a staff photographer for *Ogonyok* magazine. (Photographs pages 79, 92, 93)

SERGEI GITMAN was born in 1944 in Moscow. Before taking up photogra-phy, he worked as a Russian-English translator. His home serves as a gathering place for photographers from throughout the Soviet Union, and he has recently established FotoMost (Photo Bridge), a vehicle for organizing photographic exhibitions in the USSR and promoting Soviet photography abroad. (Photographs pages 36, 37, 68, 69, 70, 71)

EDUARD GLADKOV photographed "The Village of Tchachnitsy and All Its People" in 1982. The project began when he visited a friend there and real-ized that the community would soon disappear because young residents had no way to earn a living. "The Soviet people now have the opportunity to become normal people like everybody else in our world," he says. "As a universal means of spiritual communication, photography can significantly promote this." Eduard Gladkov was born in Moscow in 1939. He studied oceanography at Moscow State University, but abandoned it for photogra-phy three years after graduation. (Photographs pages 65, 66)

ALEXANDER GREK was born in 1950 in Georgia. He lists as the most im-portant influences on his photography Henri Cartier-Bresson, Alexander Artiunov, Kima Geikhena, and "the human race." His goal is "to continue to love people, although it isn't always easy." (Photograph page 101)

FARIT GUBAEV was born in Kazan in 1951. He names Diane Arbus, Ansel Adams, Eugene Smith, and Henri Cartier-Bresson as major influences on his work. He aims to operate with "no sort of contrivance or interference" be-tween himself and his subjects. Gubaev is a staff photographer for the news-paper *Vechernaya Kazan* (*Evening Kazan*). (Photographs pages 85, 95)

SERGEI KOROLJOV, a Leningrader born in 1952, has as his goal "to pre-serve in the common human memory the signs of our times and our city." The children by the Fontanka Canal pictured on page 127 have been resi-dents of the building behind them since birth. "This building is famous for all of us in Petersburg for the spirit of Dostoevski's writings," says Koroljov. He began photographing in 1979, and his early work was shaped by his Leningrad colleagues and the photographs of Cartier-Bresson. "Now," he says, "prerevolutionary Russian photography is my strongest influence." (Photographs pages 47, 127)

PAVEL KRIVTSOV says, "I want to arouse a sense of compassion with my photography." He is admired by Grigory Shudakov, photography critic for *Soviet Foto* magazine, who feels that "in an international medium like pho-tojournalism, Krivtsov somehow finds a Russian fragrance. He unveils things that haven't been seen for decades." Instead of looking to other photographers for inspiration, Krivtsov immerses himself in literature, music, and painting. Krivtsov was born in the village of Rozhdestvenka, in the Belgorod Region northeast of Moscow. He now works for *Ogonyok* magazine. (Photograph page 5)

NIKOLAI KULEBIAKIN tries in each of his photographs to combine several situations. "I depict these states and dimensions not straight, but indirectly," he says. Kulebiakin traces his influences to the Russian photography of the end of the last century and to "a trend in American photography represented by the F-64 group." He was born in 1959 in the Moscow Region. (Photo-graphs pages 35, 118)

LJALJA KUZNETSOVA describes herself as "a person existing in a society of oppressive laws, looking for a way out through photography." Nomadic gypsies wandering the steppes seemed at first to embody the poetry she sought. "I later understood that these people have their own cruel laws, but they remain a symbol nevertheless," she says. The circus community also seemed free of society's laws, and Kuznetsova photographed them for that reason. In her series on women, Kuznetsova wanted to trace her own destiny. "There are no happy women in my pictures," she says. "They are tragic figures, each embodying a multiplicity of selves." Kuznetsova was born in Uralsk in western Kazakhstan. In 1966, she moved to Kazan where she studied and worked as an aeronautical engineer. (Photographs pages 29, 56, 57, 59, 60, 62, 63, 64)

ALEXANDER LAPIN, a native of Moscow, was born in 1945, "eight days after the end of the Great Patriotic War against Nazi Germany." He studied at Moscow's Physics-Technical Institute, but left before graduating to pursue photography. Initially, he was influenced by Irving Penn, Robert Frank, Eugene Smith, the old *Life* magazine, Magnum, Henri Cartier-Bresson, and Andre Kertesz. Regarding his outlook and his goals, Lapin says, "There is too little good, justice, and beauty in life. In order to exist, I embrace my improved reality on photographic paper. This is my personal proof of the existence of harmony and God in the world." (Photographs pages 30, 45, 46)

VASILI MARTINKOV was born in the village of Zagorye, Shklovskiy District, Mogilev Region. He now lives in Kazan where he belongs to the photography group Tasma. "I think that the social photography which forms the basis of Tasma arouses people to reflect upon their lives and make them more humane," says Martinkov. "When we members of Tasma gather at the table to celebrate, the traditional toast is 'to our mistress,' that is, 'to photography.'" (Photograph page 74)

YURI MECHITOV was born and raised in Tbilisi where he makes his living as the still photographer for the Georgia Film Studio. "I don't claim any unique approach to picture-making," he says. "Sometimes I feel myself inside an event, sometimes outside. The main thing is to work without dogma. I use both documentary and directorial methods. My goal is to bring more of what is human into photography, so there exists between picture and viewer a field of tension in which sensations are sharpened." (Photograph page 104)

VALERI MIKHAILOV was born in 1946 in Kazan where he lives today. He learned photography by joining the city's amateur photo clubs, first the Volga group and then Tasma. Mikhailov claims that the other Tasma photographers have had the greatest influence on his work and says, "I have high regard for psychological photography." (Photographs pages 44, 73)

YEVGENI MOKHOREV was born in 1967 in Leningrad. Mokhorev says his photographic goal is to "reflect the nowness of life." He has been photographing an extensive series on children entitled "Playing In Their Own Environment." Mokhorev says of that project, "It is vital to analyze and understand the reaction of youngsters to the microworld around them." (Photograph page 103)

IGOR MOUKHIN works in themes or series. Currently he is developing three: "Fragments," "Self-portraits," and, shown in this collection, "The City." He names Lee Friedlander, Diane Arbus, Robert Frank, and Lou Reed as influences. A native of Moscow where he still lives, Moukhin was trained at a technical school for the construction industry and has worked as a heating and ventilation specialist. He has also worked as a night watchman to support his photography. (Photographs pages 89, 90, 91, 98)

MIKHAIL NASBERG describes his goal as "expressing through photographic composition and movement people's inner and outer links with their surrounding reality." Nasberg was born in 1947 in Tbilisi, Georgia, where he still lives and works. He names as photographic influences Henri Cartier-Bresson, Robert Doiseneau, Andre Kertesz, and Bruce Davidson. (Photographs pages 40, 121)

VALERI PAVLOV says, "I shoot seldom and very little." Pavlov was born in Kazan in 1953. His photography is shaped by the events of his own life rather than the work of other photographers. His goal "is to narrate and tell people about that which I myself do not yet know. That which I already know is no longer of interest to me. I want to see what is over there, around the corner." (Photograph page 77)

YEVGENI RASKOPOV organized the Zerkalo (Mirror) photography club in Leningrad in 1969 and still leads it. His goal is "to leave in people's minds all the uniqueness and diversity of the times in which my life was spent." He describes himself as a devotee of Henri Cartier-Bresson and Soviet photographers Pavel Krivtsov and Vladimir Vyatkin. Raskopov's favorite camera subject is Dagestan. "I dearly love its faithfulness to old traditions and customs, and I have been visiting the region for twelve years now," he says. Raskopov was born in 1936 in the town of Kizel in the Ural Mountains. (Photograph page 97)

YURI ROST, primarily a portrait photographer, takes photographs of and writes about Soviet cultural and political figures, often placing his subjects in environments that reveal something about their concerns. His work is published in popular periodicals and exhibited in Soviet galleries. Rost was born in 1939 in Moscow and still lives there. He names Nikolai Gogol and Henri Cartier-Bresson as influences on his work. (Photograph page 116)

YURI RYBTCHINSKI believes that culture has a strong influence on photography in general and on his work in particular. As for his technique, Rybtchinski says, "I prefer to shoot without looking in the viewfinder, and I don't press the shutter release until the idea has clutched my finger." Rybtchinski was born in 1935 near the Sea of Azov in Berdiansk. He arrived in Moscow in 1954, where he earned a degree in geology. He worked for a number of years as a writer and finally took up photography in 1970. (Photographs pages 26, 32, 33, 42, 75, 81, 82, 83)

BORIS SAVELEV's photographs have several levels of meaning in which light, form, space, and events combine in a personal viewpoint. For him, photography is a highly intellectual pursuit. It is also "the cleanest art, and I

want to show this," he says. Savelev was born in 1947 in the Ukrainian town of Chernovtsy. He moved to Moscow in 1966, where he studied aviation engineering, a profession he practiced until 1983 when he became a full-time photographer. (Photographs pages 34, 39)

VASILI SHAPOSHNIKOV was born in 1965 in the town of Vorkuta in western Siberia. He studied at the Donetsk Polytechnical Institute and Moscow State University. "I feel that the photographer is the instrument for the creation of a new world," he says. "The right to select the photographic moment belongs to the photographer, and thus the photograph ceases to be a naked fact." (Photographs pages 43, 94, 106)

VICTOR SHUROV was born in Zelenodol'sk in the Tatar Region. He now lives and works in Leningrad where he has a sophisticated downtown studio, a far cry from the spartan facilities of most of the photographers whose work appears in this collection. His good fortune is explained by the fact that he does commercial work in addition to photography with a social orientation. Shurov names Ansel Adams and Bill Brandt as photographers who have influenced his work. (Photographs pages 88, 119)

VLADIMIR SIOMIN was born in Tula, south of Moscow, in 1938. He studied mechanical engineering and practiced his profession until he was drafted. "The army needed photographers, so I became one," says Siomin. "Then photography changed from a hobby into day-to-day work, until Henri Cartier-Bresson turned my conception of photography upside down." Now Siomin says he uses photography "to help myself recognize and analyze life, and to help others to love and value the same. My camera is my weapon for these ends." (Photographs pages 50, 54, 55, 61, 87, 100, 125)

BORIS SMELOV joined the photo club at the Vyborg Palace of Culture in Leningrad at age eighteen. "Then I began to work as a photographer, first at a publishing house, then in the Literary Foundation, and now as a freelancer." Smelov admires the work of Jacque Henri Lartique, Henri Cartier-Bresson, Brassai, Bill Brandt, Ansel Adams, Diane Arbus, Alexander Rodchenko, and Joseph Sudek. He was born in 1951 in Leningrad. (Photographs pages 48, 76, 109)

NIKOLAI SMILYK became a photographer eighteen years ago. His goal is "to portray life as it is, by simple means that are comprehensible to the man in the street." (Photograph page 72)

VLADIMIR SOKOLAYEV perceives in himself "the ability to discover inner connections in the world of forms through the medium of photography." Sokolayev's world view is shaped by Western and Oriental philosophical and religious literature. He was born in Novokuznetsk in 1952 and has been deeply concerned about the pollution of his native city by the coal mines and steelworks there. He has dedicated his camera to bringing about public awareness of the problem. (Photographs pages 114, 115)

ALEXANDER STEPANENKO was born in 1964 in Kirovsk in the northwestern Murmansk Region. He took up photography in 1979, and says, "Life is the

most important influence on my work, as well as Maria Fyodorovna Kedrova, my first teacher at school, and Soviet photographers Pavel Krivtsov and Vladimir Vyatkin." (Photograph page 99)

VYATCHESLAV TARNOVETSKI says, "My photography is autobiographical. My goal is to create my own photo history from provincial life." His pictures combine a documentary, contemplative, and poetic approach. Tarnovetski was born in the Ukrainian town of Chernovtsy in 1945. He has degrees in optical physics and photographic chemistry and teaches in a technical college in his hometown. He says, "At first Josef Sudek influenced my work; later it was Diane Arbus. Now no one does." (Photographs pages 51, 52, 102, 126)

DMITRI VYSHEMIRSKY was born in 1958. In the Soviet Union, his work has appeared in republic and all-union photographic exhibitions, and in 1988, he won the Ogonyok Magazine Prize. Vyshemirsky has participated in international exhibitions as well. His spring 1990 one-man show was entitled "The Small Golden Shadow: Stalin's Kolyma Camps." (Photograph page 2)

RIFKHAT YAKUPOV believes photography can effect social change and wants his own pictures to do so. "Objective information was practically arrested in our country during the years of stagnation," he says. "Communist doctrine regarding interethnic relations threatened my people, the Tatars; through my work, I want to promote the rebirth and consolidation of the Tatar people." Yakupov was born in 1944 in the town of Izhevsk, northeast of Kazan. (Photographs pages 58, 120)

MARINA YURCHENKO became interested in photography while working as a photo editor for the Novosti Press Agency. She does not believe her approach to photography is unique, but she does consider photography a "powerful channel of information through which people of various nationalities, races, and religions may communicate." For Yurchenko, "every photograph is a small short story, sonnet, or tale." Yurchenko was born in 1956 in Moscow where she still lives. (Photographs pages 122, 123)

YURI ZHURAVSKI was born in the Ukrainian city of Lvov in 1954. He now lives in Leningrad where he belongs to the Zerkalo (Mirror) photo club and works under the guidance of Yevgeni Raskopov. He considers photography "an unceasing process to one's own self," and through his work he hopes to "creep up to the truth." (Photograph page 124)

VLADIMIR ZOTOV accuses the Soviet press of destroying talented photographers, "making embellishers of truth out of them, animating the inner censor in them." Zotov was born in Kazan in 1939. "I was lucky in Kazan," he says. "The creative group called Tasma united us in our aspiration to see ourselves via the creations of great masters. Despite the paucity of information and access, many world-class photographers influenced us, most of all Henri Cartier-Bresson." Does Zotov feel the Kazan or Russian approach to photography is unique? "No, we are probably derivative," he says, "but I am certain that our photography has a great vital force." (Photograph page 96)

ACKNOWLEDGMENTS

Because of the special conditions prevailing in the Soviet Union, a project of this nature would have been impossible without the help of people ready to put up with hardships and frustrations. Many did so simply because they believed in the worth of this book.

My deepest debt is to the Soviet photographers. Their drive to overcome difficult working conditions and obstacles to expression has been an inspiration to me. Their warmth, idealism, and passion for photography have, most of all, given meaning to this enterprise.

I am very grateful to Frances Fralin of The Corcoran Gallery of Art for her support and cooperation. Working with Frances as curator of the exhibition has been extremely rewarding.

I owe particular gratitude to Nikolai Romanov for his excellent language translation and logistical support, and for never counting the hours it took to make sure pictures and photographers were at the right place at the right time.

Special thanks also goes to Felix Rosenthal, manager of Moscow's Time/Life office, for help with communications and shipping, and for sensible guidance on dealing with the intricacies of Soviet institutions.

For providing access to and obtaining historical photographs, I am indebted to Novosti Publishing, especially Alexei Pushkov, Konstantin Likutov, and Tanya Makarova; and from the Novosti Washington office, Sergei Ivanko and Vladimir Zaretsky. Thanks are also due to the Krasnagorsk State Archives and the Central State Archives of Cinematic and Photo Documents, Leningrad, for access to their historical collections.

For insightful and constructive reading of the manuscript, I thank Elizabeth Newhouse, Naftali Bendavid-Val, and Harry Val.

I called on many people for organizational support, translations, and feedback as the project progressed: Declan Haun, Bill Wright, David Ross, Michael Frost, Shelley Sperry, Laurie Smith, Mark Berkovich, and Mary Nash. All have my profound thanks.

It has been a great pleasure to work with Starwood Publishing, especially Carolyn Clark and Doug Elliott, who have been not only knowledgeable and concerned, but enthusiastic and innovative in their approach to this project.